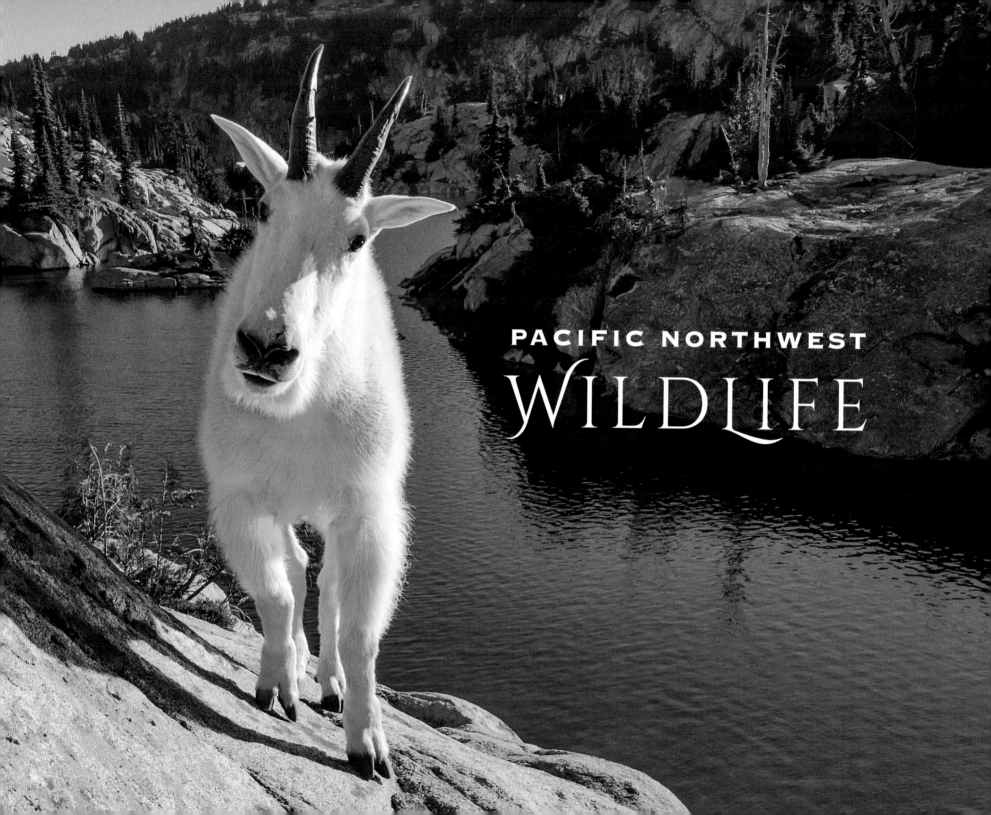

PACIFIC NORTHWEST
WILDLIFE

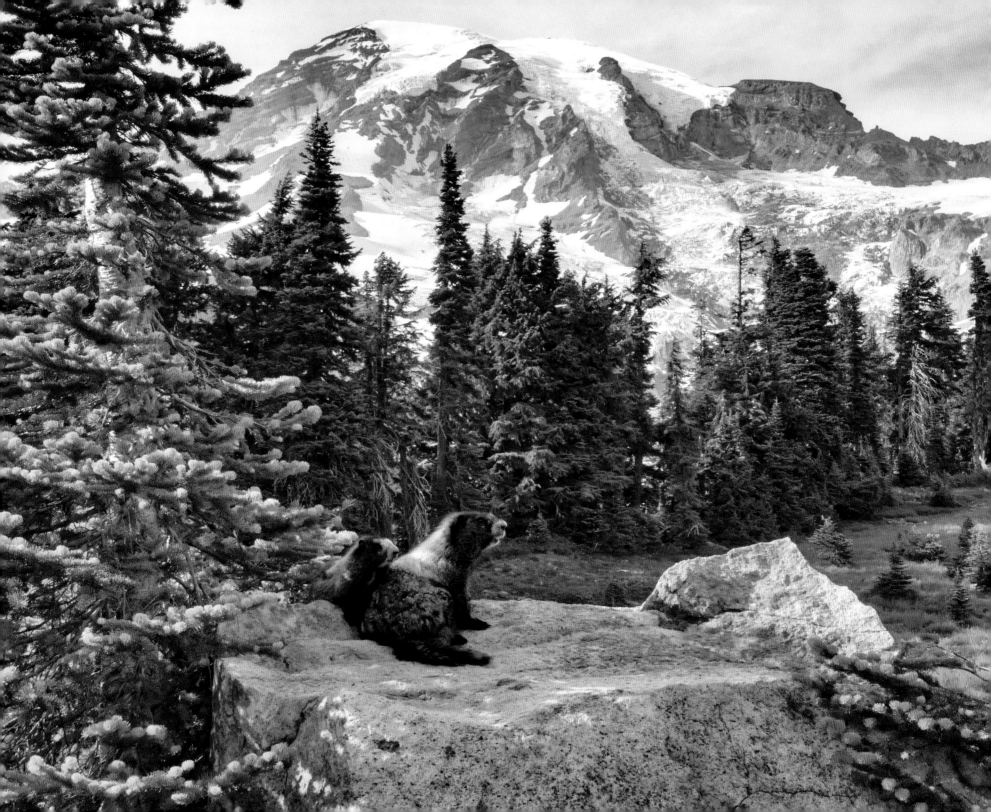

PACIFIC NORTHWEST
WILDLIFE

AARON BAGGENSTOS

NATURE'S PRIME
PUBLISHING

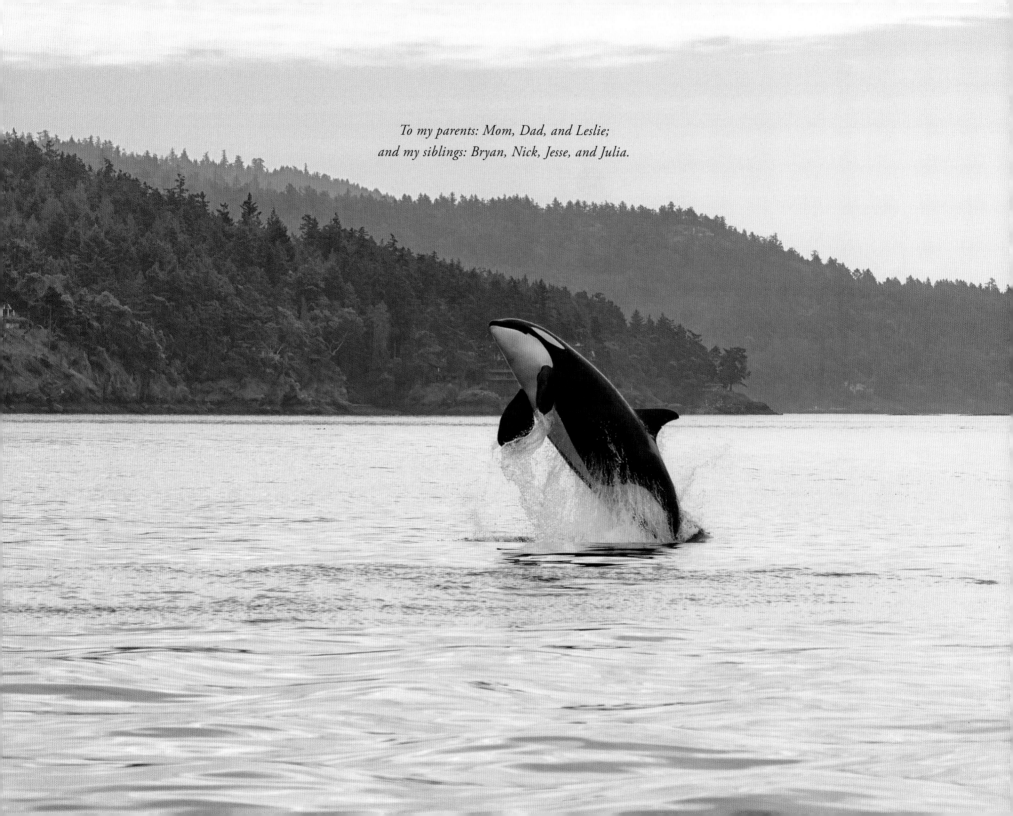

To my parents: Mom, Dad, and Leslie;
and my siblings: Bryan, Nick, Jesse, and Julia.

CONTENTS

INTRODUCTION ∼ 1

 FOREST ∼ 5

 MOUNTAIN ∼ 27

 FRESH WATER ∼ 39

 GRASSLAND ∼ 57

 ISLAND AND OCEAN ∼ 79

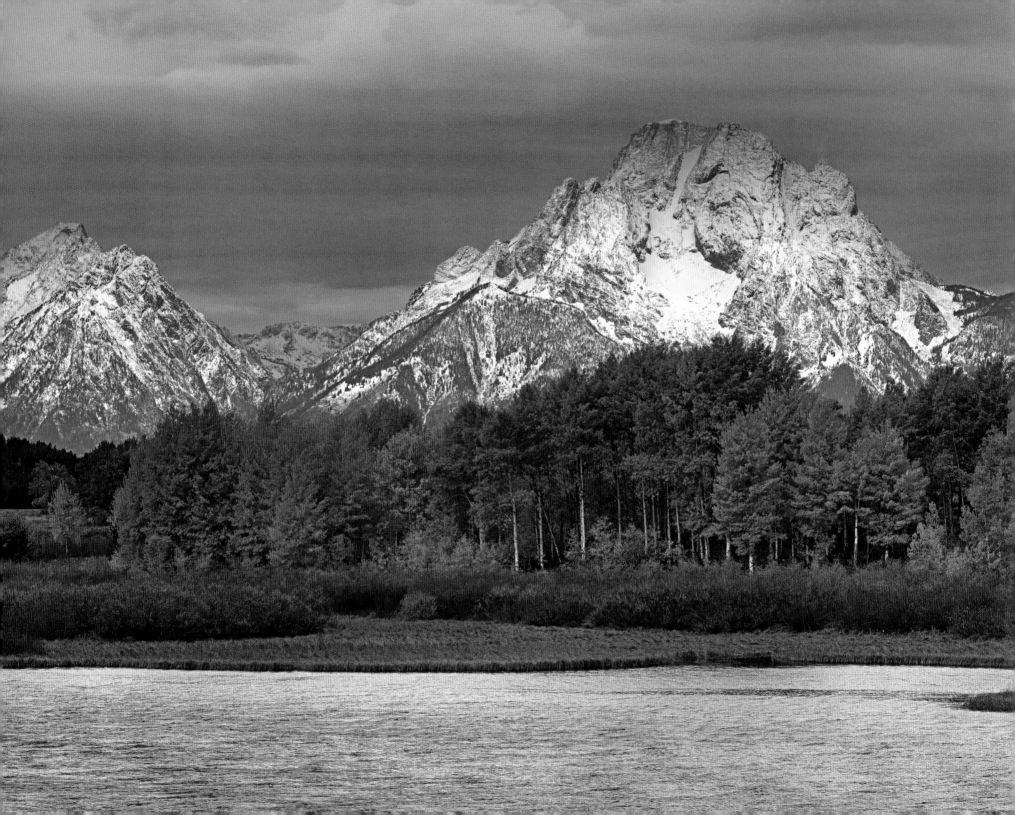

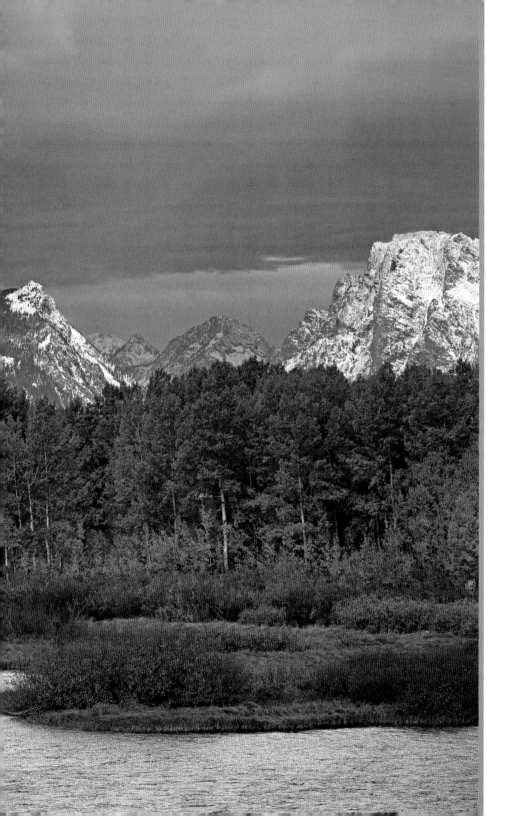

INTRODUCTION

The Pacific Northwest is home to some of North America's last remaining wildlands. The region's geography, weather, and proximity to the Pacific Ocean create a surprising variety of habitats. In this region alone, you'll find snow-capped mountain ranges, glaciers, active volcanoes, temperate rainforests, ocean shorelines, expansive river basins, large mudflats, wetlands, and cold deserts—a varied landscape that hosts a rich diversity of animals, making it one of the most amazing places on the planet for wildlife photography.

I have lived in the Pacific Northwest my entire life. My photographic journeys have taken me to some of the wildest and most remote places on earth: I have driven into Africa's famed Maasai Mara to photograph lions, trekked through sub-zero temperatures in the Arctic to photograph 800-pound polar bears, and

Left: Fresh October snow contrasts with resplendent aspen color, Mount Moran, Grand Teton National Park.

Above: Aaron photographing owls in the Skagit Valley, Washington State.

1

floated by wooden canoe into the heart of the Amazon jungle searching for jaguars. Though these areas and their wildlife are magnificent, my travels have reinforced my conviction that the Pacific Northwest hosts some of the world's most spectacular wild places and wild animals.

In a few hours' drive from my home, depending on the direction, I can observe a surprising number of unique wildlife spectacles including orca whales breaching with a backdrop of stunning island scenery, bears fishing for salmon along pristine rivers, and one of the world's largest concentrations of bald eagles.

In the last three years I've spent more than 600 days photographing wildlife in the Pacific Northwest. I feel privileged to have witnessed extraordinary encounters with some of the region's most fascinating creatures. All photos in this book were taken in natural habitats except those of the two animals that have eluded my camera thus far in the wild—the mountain lion and the lynx. My hope is that by sharing these images you will gain a new sense of wonder and appreciation for this magnificent region and the wild animals that live here.

The earth is rapidly changing and people need to take a more active role in protecting our fragile planet. Scientists and travelers in this region have witnessed forests disappearing and glaciers melting. Many of the animals photographed in this book survive within fragmented habitats that are our national parks, national forests, and other public lands. If we fragment these remaining natural areas any further, we risk losing the creatures that live there. All that will remain are memories and photographs. It is increasingly important that we protect an array of wildlife habitat to prevent that from happening.

I hope you enjoy this book as much as I did creating it.

See you in the wild,

Aaron Baggenstos

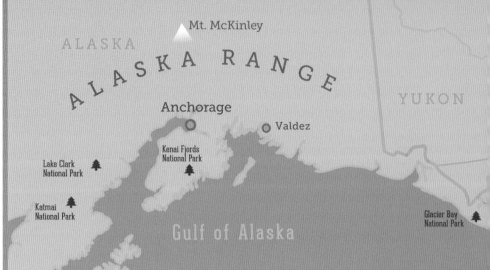

The Pacific Northwest is a geographical region bordered by the Pacific Ocean on the west and loosely by the Rocky Mountains on the east. People do not all agree on an exact boundary for the Pacific Northwest and, as a result, a variety of definitions have developed over time that can be attributed to history, geography, and other factors. For the purpose of this book, I have included photographs from the greater northwest corner of North America spanning Washington, Oregon, British Columbia, Alberta, southern Alaska, Idaho, and small sections of western Montana and western Wyoming.

The book is divided into general habitat sections. Markers on the map to the right indicate where most of the book's photographs were taken. Location-specific information is included in many of the photographic descriptions as well. Some of the animals in this book can be found in any or all of the habitats. This book highlights some of my favorite species and is in no way meant to be a comprehensive representation of the region's massive biological diversity.

For my fellow photographers I've listed the camera equipment and settings that I used to take each photograph in this book on my website at this link:

www.AaronsTours.com/ResourcesForPhotographers

I shot most of these images with a long telephoto lens enabling me to intimately capture my subjects from a safe distance without disturbing the animals. For those of you who don't have a powerful telephoto camera lens, I recommend obtaining a good pair of binoculars.

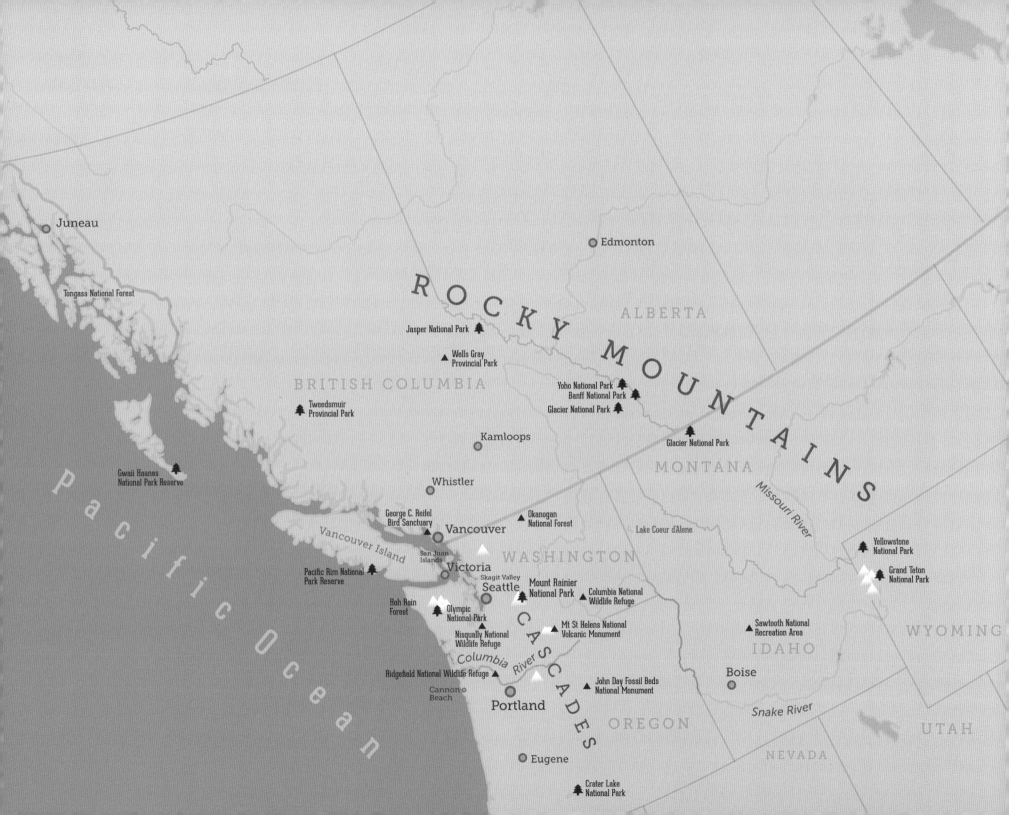

Juneau

Edmonton

Tongass National Forest

ROCKY

ALBERTA

Jasper National Park ▲

Wells Gray
Provincial Park ▲

BRITISH COLUMBIA

MOUNTAINS

Yoho National Park 🌲
Banff National Park 🌲
Glacier National Park 🌲

Tweedsmuir 🌲
Provincial Park

Kamloops

Glacier National Park 🌲

MONTANA

Gwaii Haanas 🌲
National Park Reserve

Whistler

Missouri River

George C. Reifel
Bird Sanctuary ▲ Vancouver

Okanogan 🌲
National Forest

Lake Coeur d'Alene

Yellowstone 🌲
National Park

WASHINGTON

Pacific Ocean

Vancouver Island

San Juan
Islands

Victoria

Skagit Valley

Seattle

Mount Rainier
National Park

Columbia National 🌲
Wildlife Refuge

Grand Teton
National Park

Pacific Rim National 🌲
Park Reserve

Hoh Rain
Forest

Olympic ▲
National Park

Nisqually National ▲
Wildlife Refuge

CASCADES

Mt St Helens National ▲
Volcanic Monument

Sawtooth National ▲
Recreation Area

WYOMING

IDAHO

Columbia

River

Boise

Ridgefield National Wildlife Refuge ▲

John Day Fossil Beds ▲
National Monument

Cannon
Beach

Portland

OREGON

Snake River

UTAH

Eugene

NEVADA

Crater Lake ▲
National Park

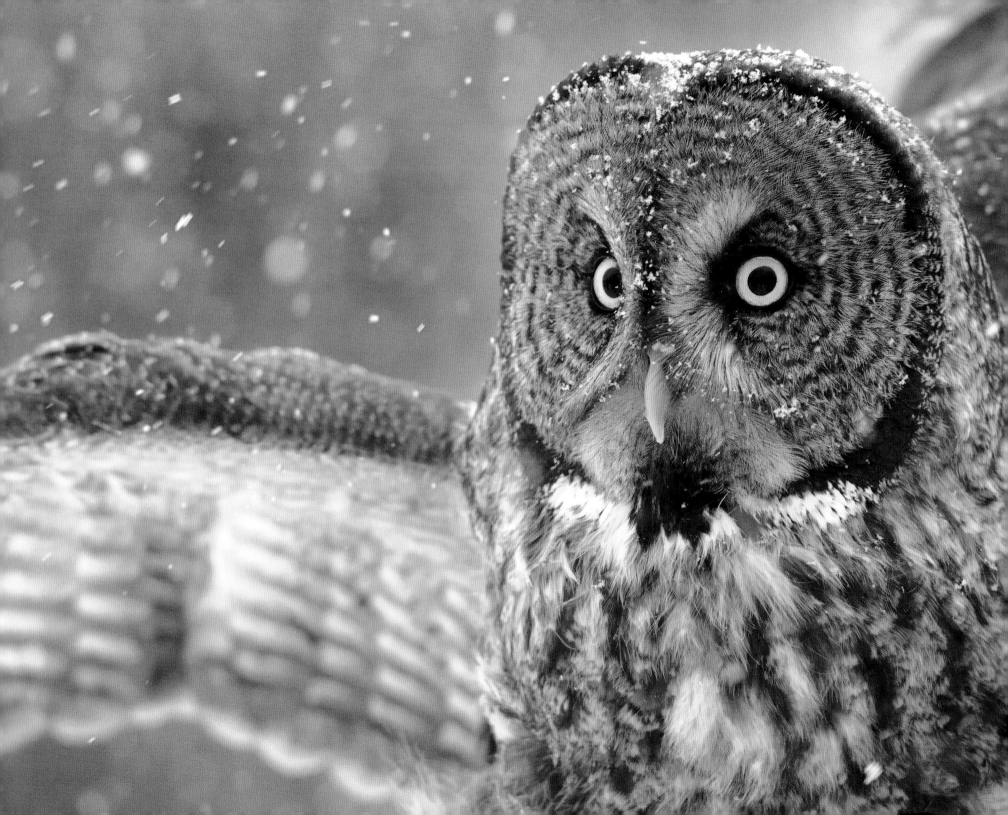

FOREST

Next time you stroll through a forest I challenge you to slow down. Become aware of your senses. Living things: insects and small animals who inhabit the forest floor, birds, and even mega fauna, might fly or slip away unnoticed unless you slow your pace. The wonders of the forest are all around you, waiting to be discovered.

The Pacific Northwest harbors the largest old-growth temperate rainforests on earth. In college I sadly learned that 90 percent of these forests in my home state had been cut down by humans. We need to protect the remaining vestiges of this important habitat—not only for the wildlife that live there but also for future human generations to enjoy the peacefulness of wild places.

Above: A black bear cub climbs a tree to gain a better vantage point.

Left: A great gray owl, North America's largest owl species.

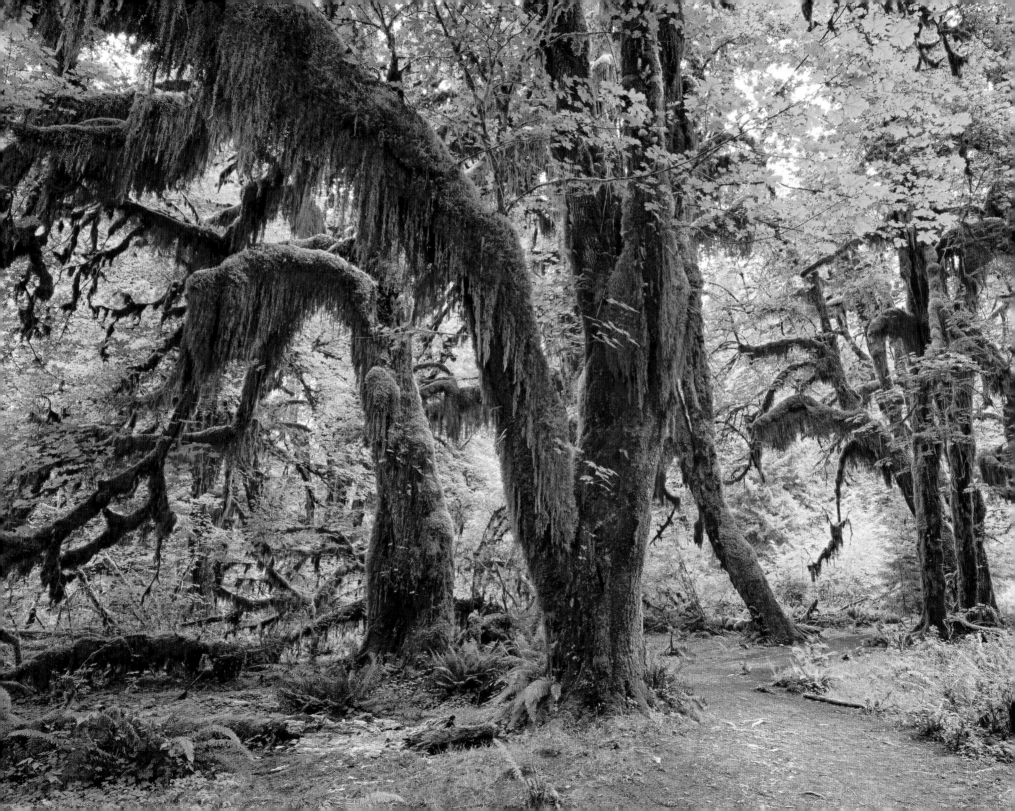

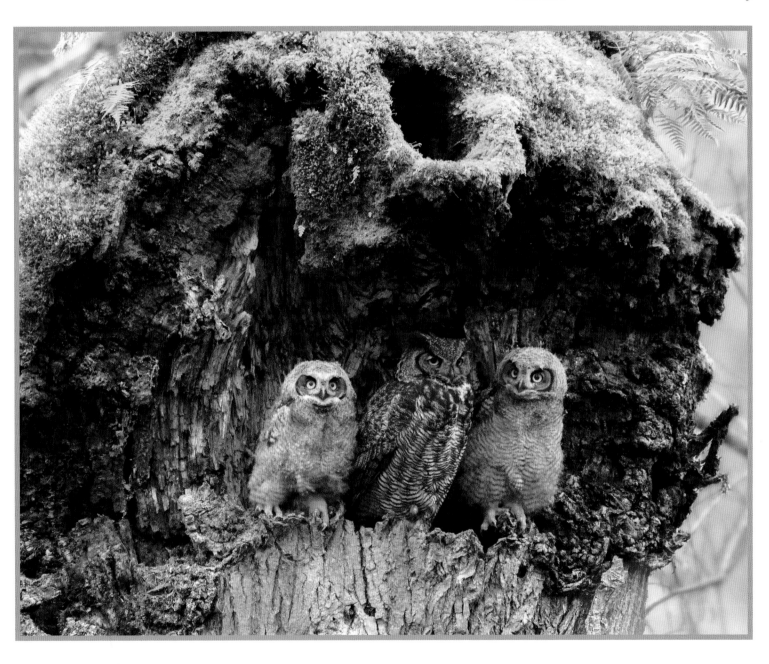

Left: Walking through the Hall of Mosses in Olympic National Park's Hoh Rain Forest seemingly stops time and heightens your awareness of this verdant retreat.

Above: A family of great horned owls perched in front of their tree-cavity nest in the Nisqually National Wildlife Refuge.

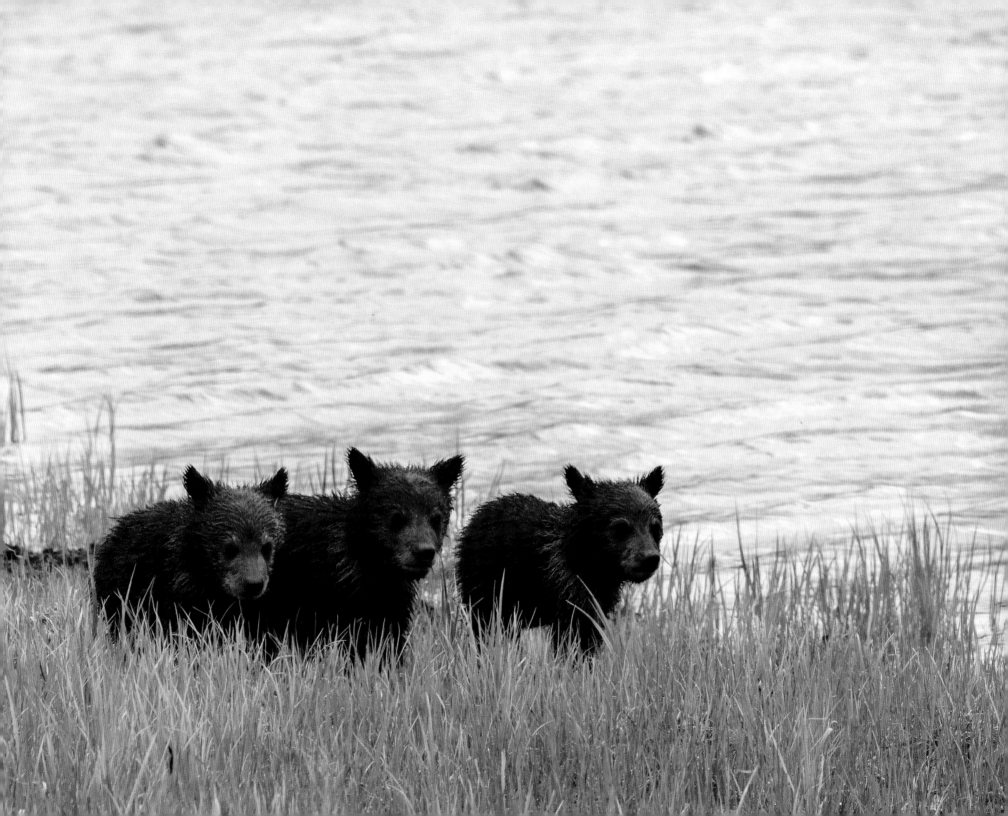

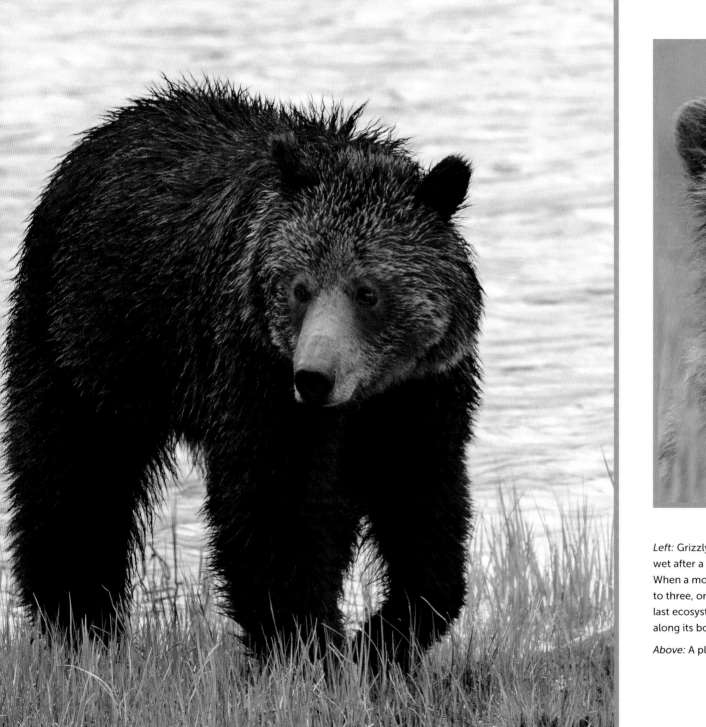

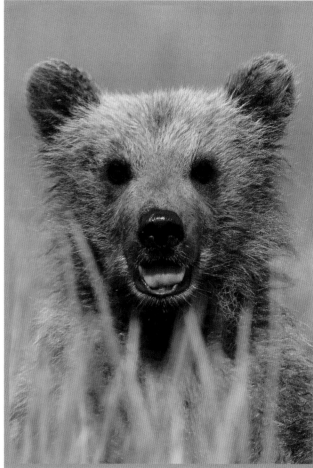

Left: Grizzly bear sow and three cubs-of-the-year. The cubs are wet after a swim at North Twin Lake, Yellowstone National Park. When a mother bear's nutrition is very good, she may give birth to three, or rarely, four cubs. The park is the heart of one of the last ecosystems where grizzlies can live, though development along its borders threaten the bears' continued survival.

Above: A playful coastal brown bear cub.

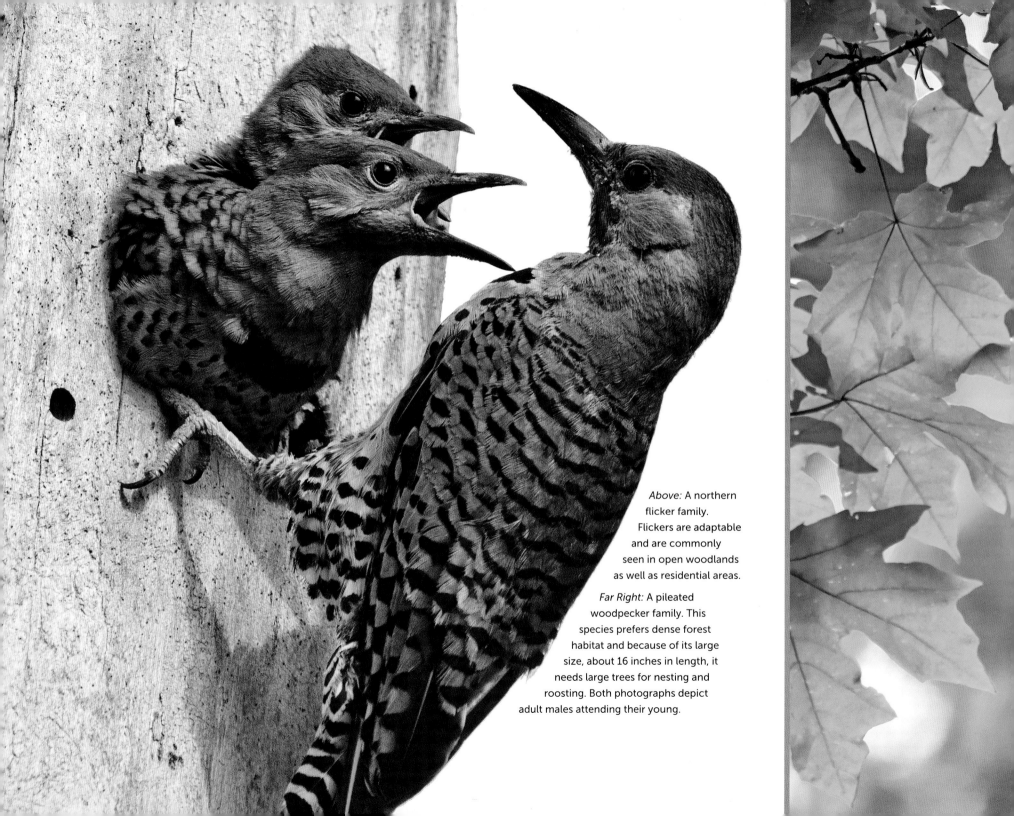

Above: A northern flicker family. Flickers are adaptable and are commonly seen in open woodlands as well as residential areas.

Far Right: A pileated woodpecker family. This species prefers dense forest habitat and because of its large size, about 16 inches in length, it needs large trees for nesting and roosting. Both photographs depict adult males attending their young.

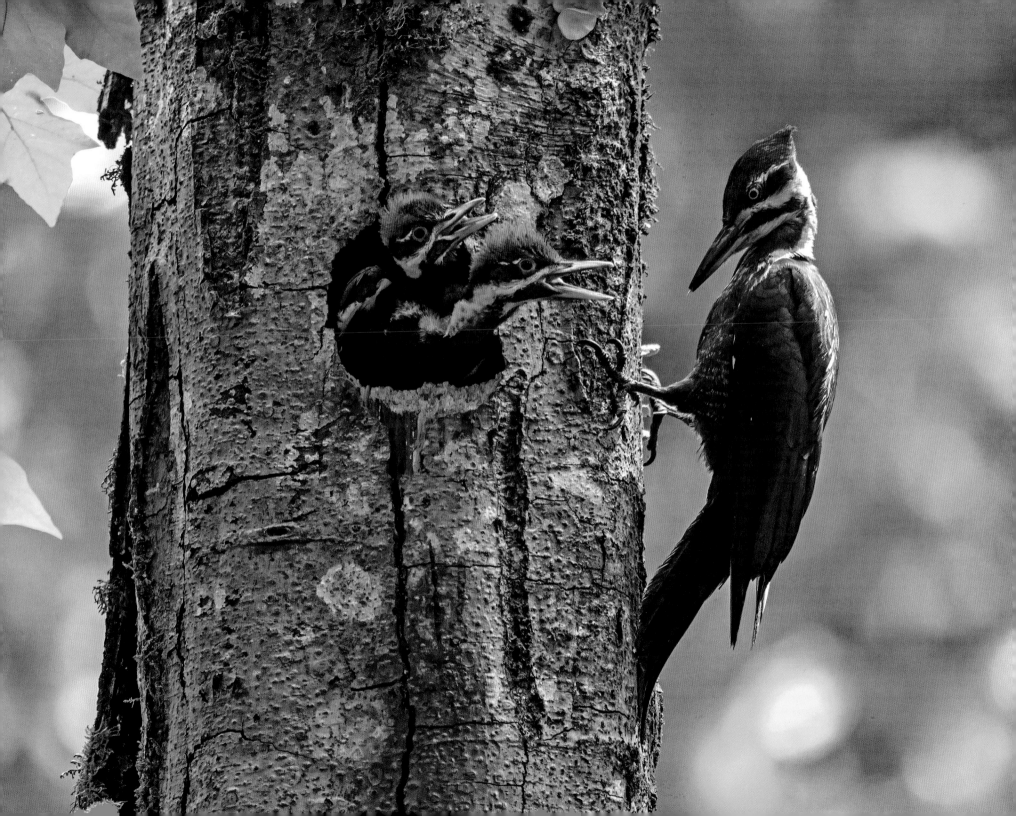

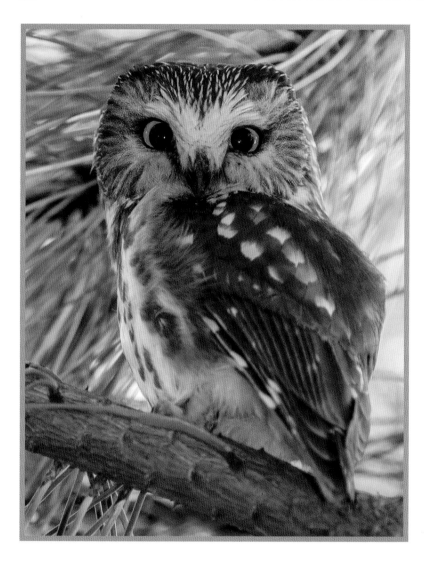

Above: A curious northern saw-whet owl.

Right: Mountain lions are the largest wildcat in North America—they can be 6 to 8 feet long (including the tail) but are seldom glimpsed despite their widespread range. I took this photo at Northwest Trek Wildlife Park in Eatonville, Washington. It is a stunningly beautiful place to observe and photograph the Pacific Northwest's exciting yet elusive animals up close in captivity.

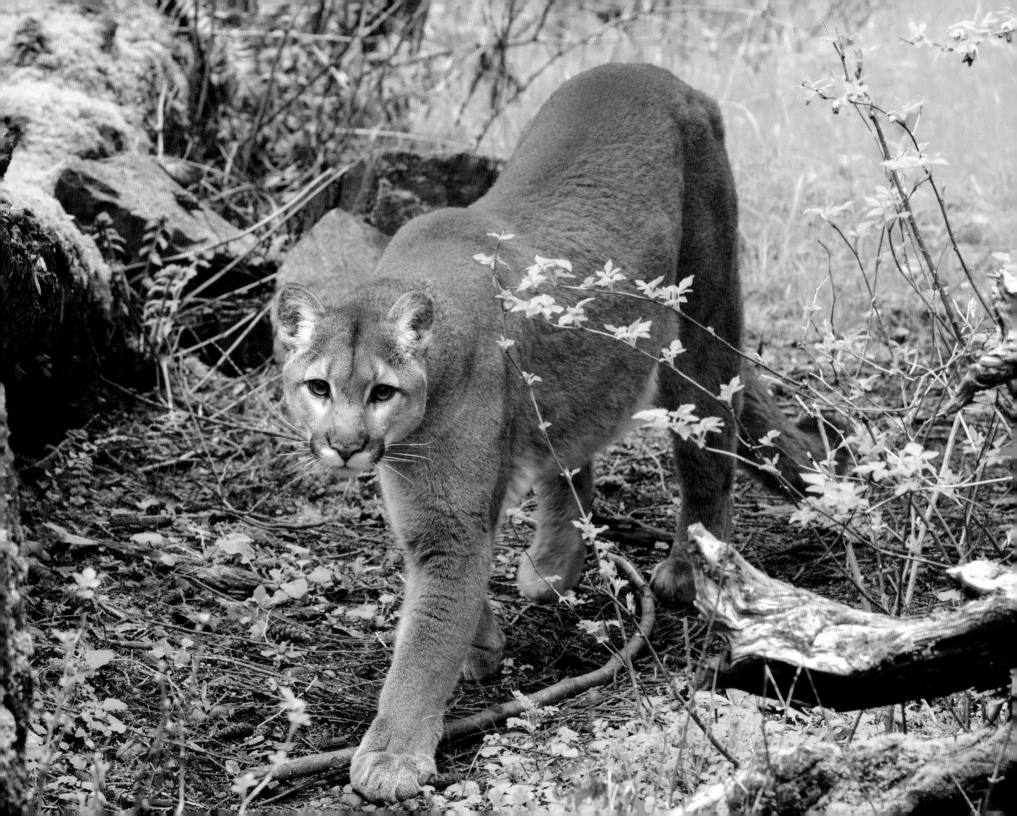

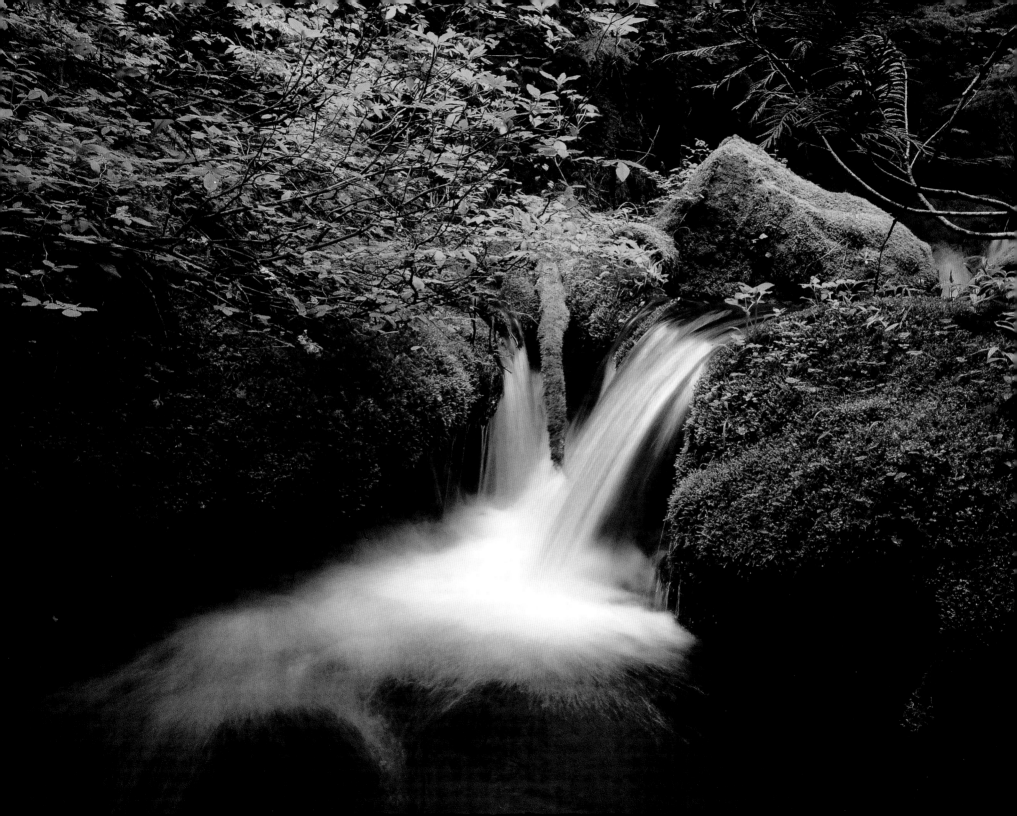

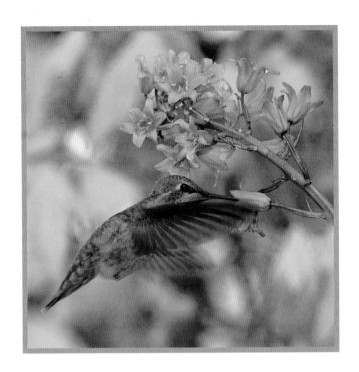

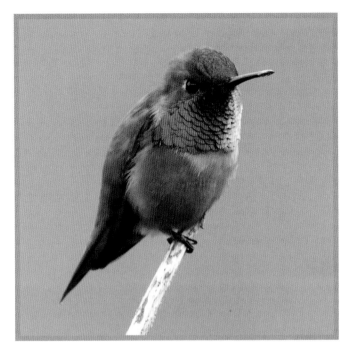

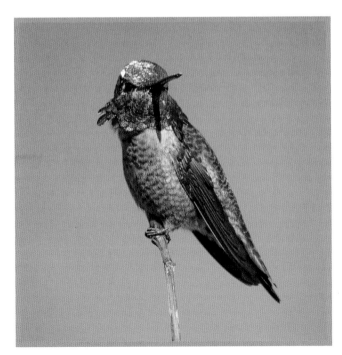

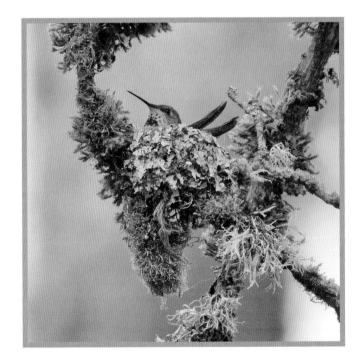

Facing Page: A small forest stream flows peacefully in Mt. Rainier National Park.

Top Left: A female Anna's hummingbird hovers while sipping nectar from a flower. This is one of five species of hummingbird that live or breed in the Pacific Northwest.

Top Right: A male rufous hummingbird. Hummingbirds are magical creatures in the natural world. They can flap their wings up to 80 beats per second, travel up to 45 miles an hour, and are the only birds in the world that can fly backwards for any distance.

Bottom Left: The iridescent head and throat of a male Anna's hummingbird is deep magenta—a stunning flash of color as it whizzes past you. Its range has expanded and includes much of the lowlands and mountains of the Pacific Northwest.

Bottom Right: A female rufous hummingbird incubates her eggs which are about the size of Tic-Tac mints.

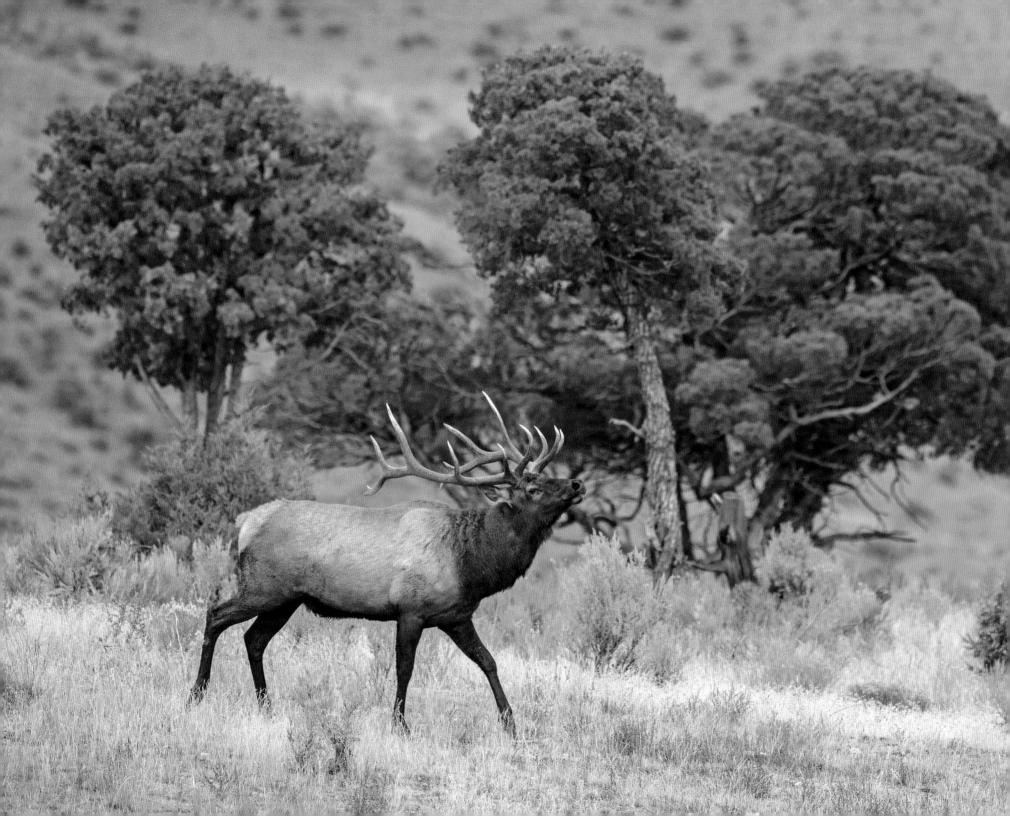

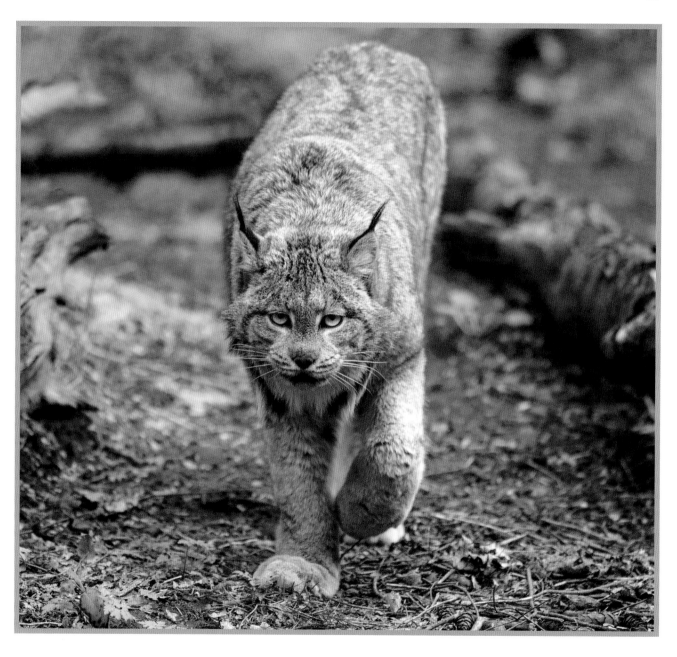

Above: Canada lynx are elusive, solitary animals that are more active at night. They live in mountainous and snowy areas in the north. Lynx populations fluctuate with the populations of their prey—snowshoe hares. This animal was photographed in captivity.

Left: A bull elk expends a lot of energy during its fall rut, competing for females and defending its harem of cows.

Below: A northern hawk owl at last light with its dinner—a vole. This owl lives in forests of the far north, primarily in Canada, but if the weather is severe or prey is scarce, it "irrupts" or moves south into the northern continental United States.

Right: A northern hawk owl is a keen hunter that hunts primarily by day. Amazingly, it can see and hear its prey under a foot of snow.

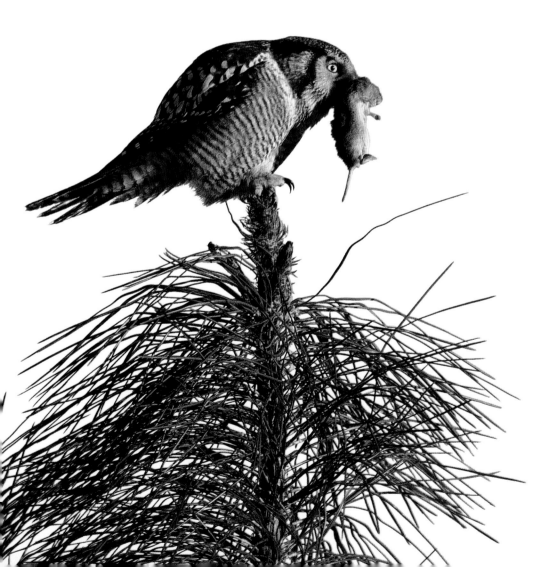

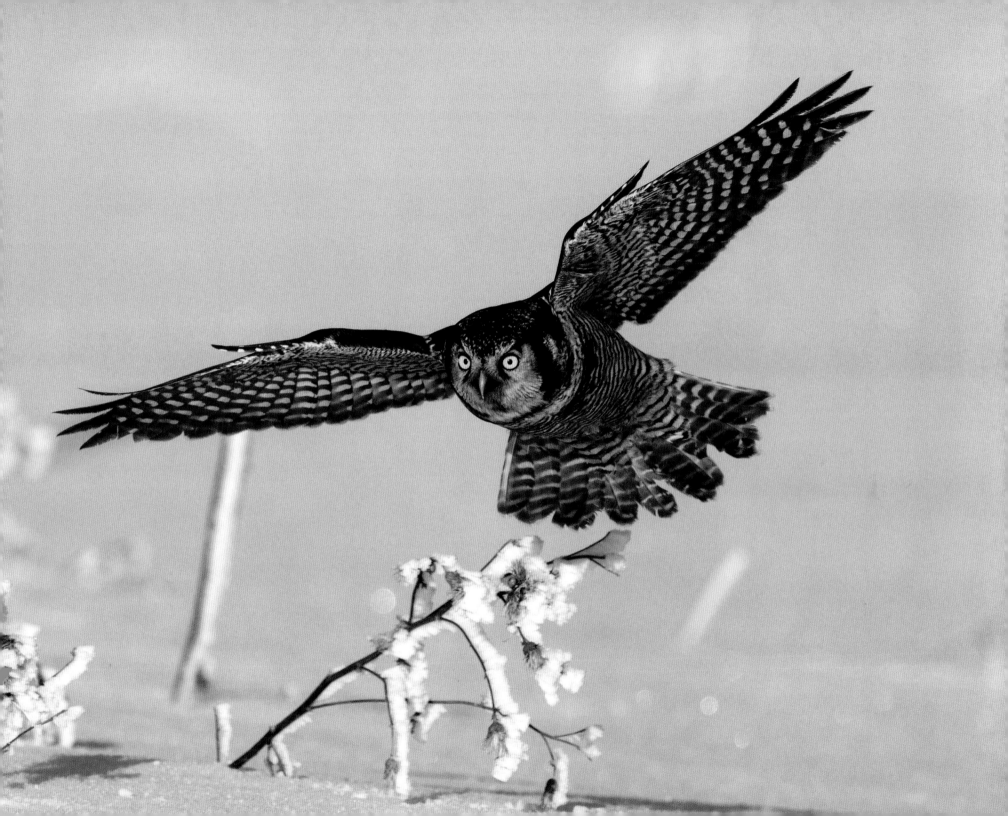

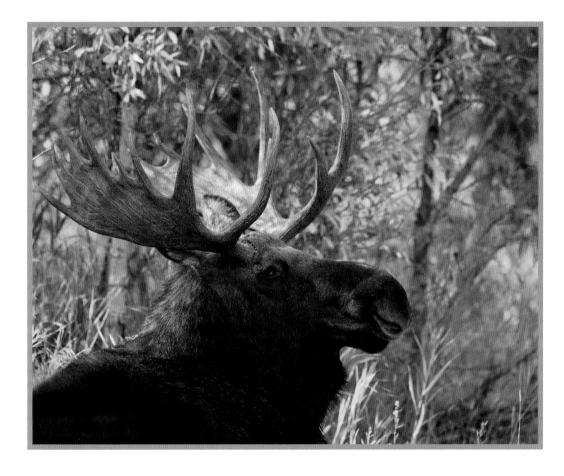

Above and Far Right: A bull moose in Grand Teton National Park, Wyoming. A male weighs about 1,000 pounds on average and its shoulder height averages 7.5 feet. By age five, its rack spans up to 6.5 feet.

Right: Moose calf and mother crossing a river. Like other species, the female is very protective of its young and the family should never be approached.

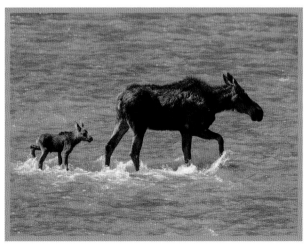

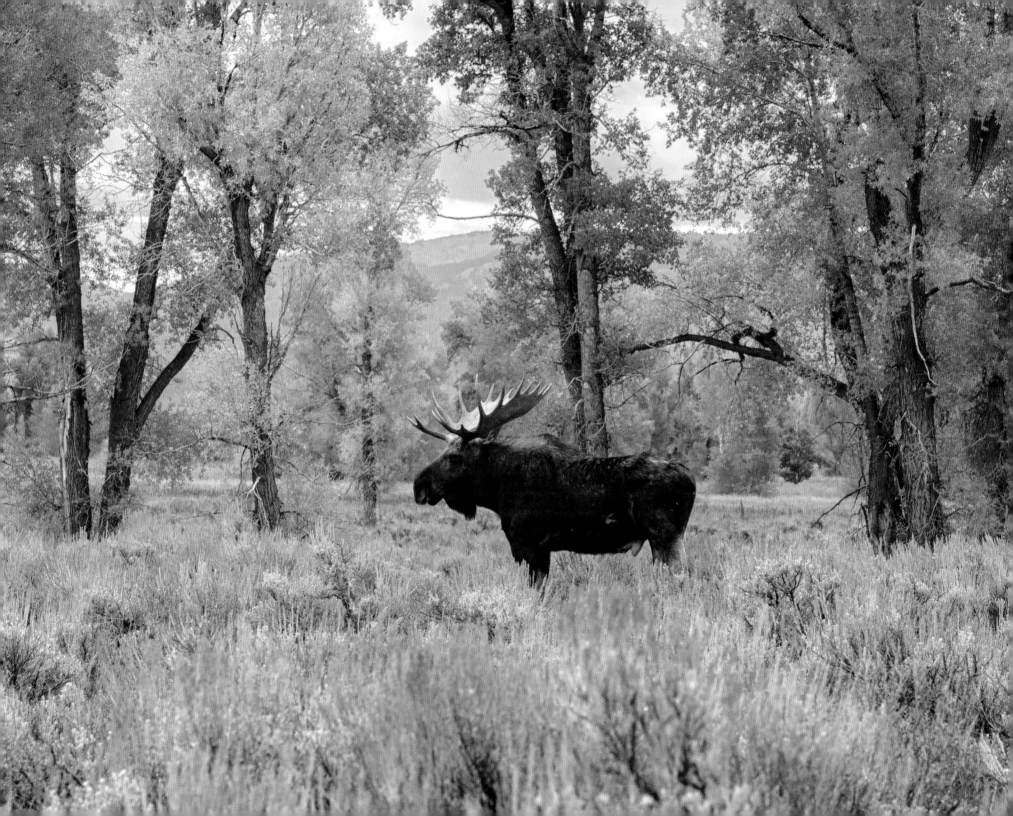

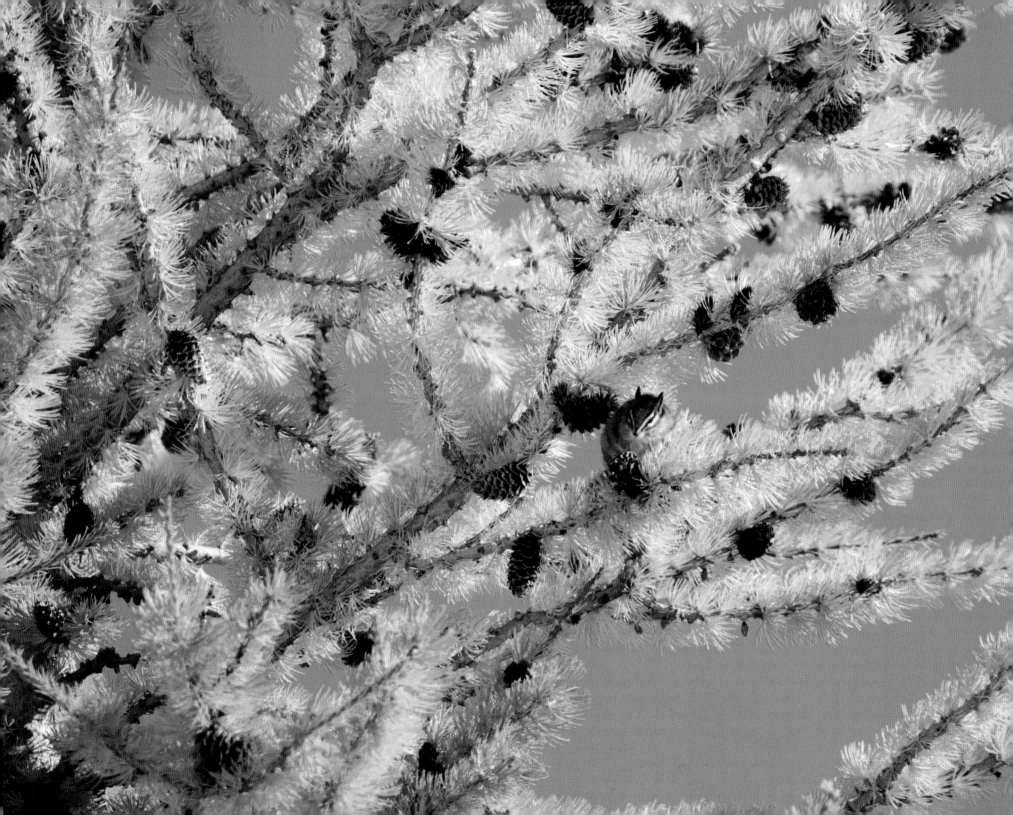

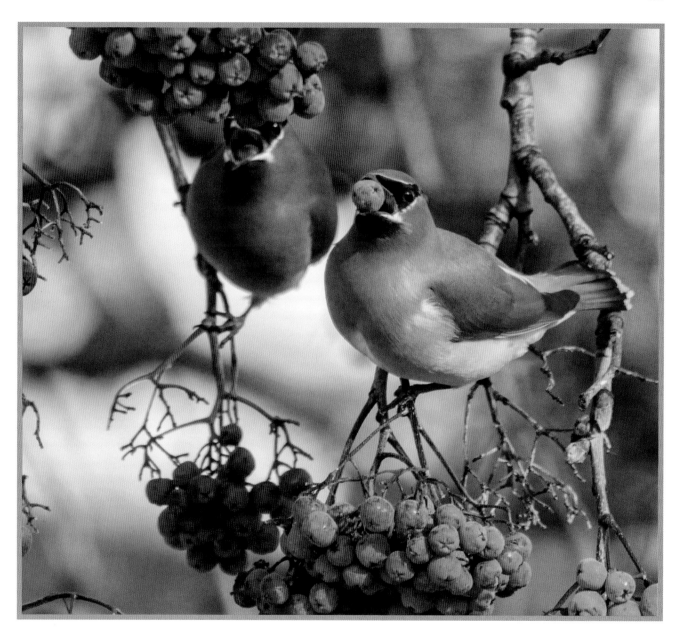

Above: Cedar waxwings swallow mountain ash berries whole. Their diet consists primarily of fruit.

Left: A chipmunk eating seeds from a western larch cone. This tree is one of only a few deciduous conifers—they turn a brilliant yellow in fall and lose their needles. Larches grow primarily in northeastern Washington and Oregon, northern Idaho, and western Montana.

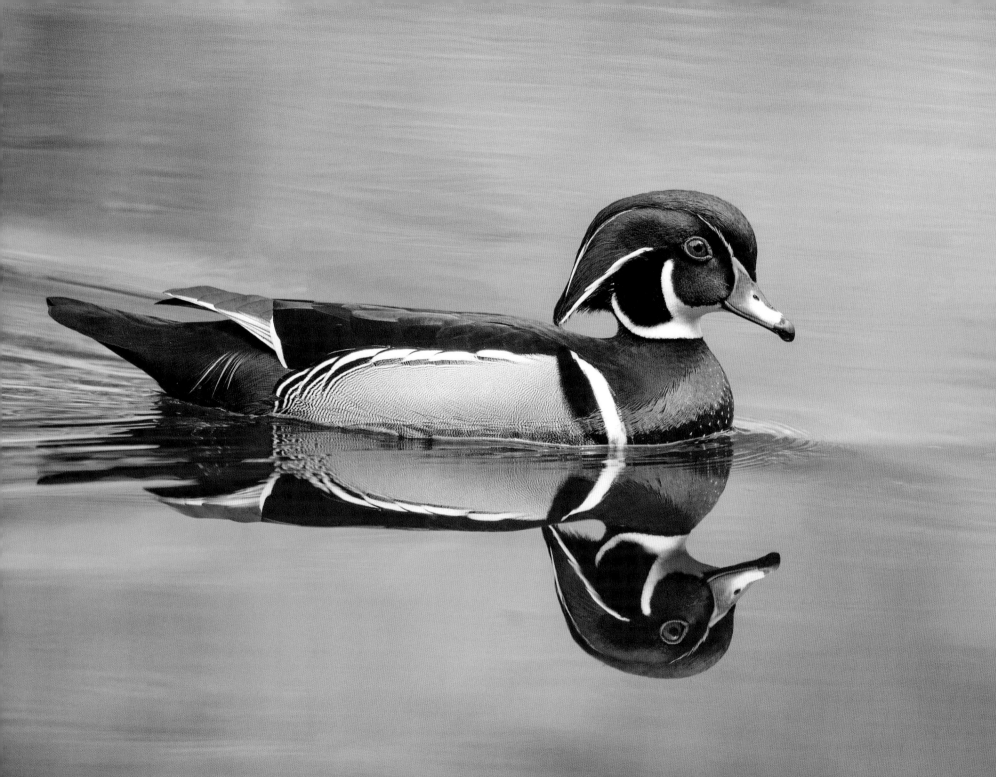

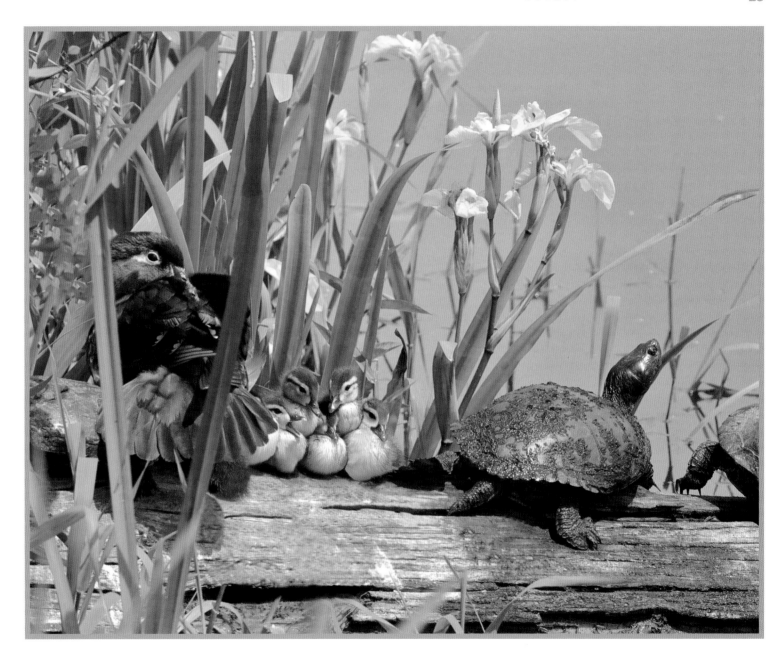

Left: The colors and patterns in the male wood duck's plumage are striking. Federal protection under a Migratory Bird Treaty Act helped their population rebound after they were hunted nearly to extinction in the late 19th century.

Above: Wood duck ducklings huddle together next to their mother in late spring, conserving heat alongside non-native red-eared slider turtles.

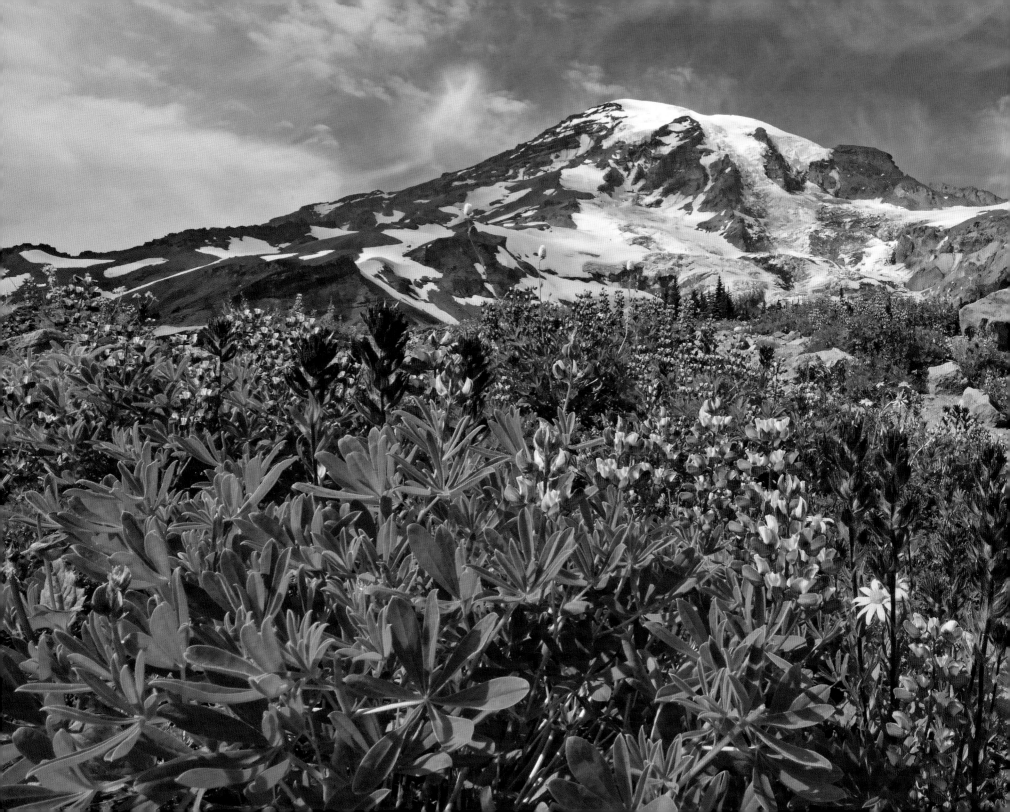

MOUNTAIN

"Climb the mountains and get their good tidings. Nature's peace will flow into you as sunshine flows into trees. The winds will blow their own freshness into you, and the storms their energy, while cares will drop off like autumn leaves."

 ∽ John Muir

Hiking and camping in the mountains makes you feel rejuvenated. Perhaps it is because of the abundance you experience—the amount of effort required to get there, the enormity of the mountains, the diversity of the forests, the colorful palette represented in a field of flowers, and of course, the amazing wildlife who live there. My experiences as a youth backpacking with friends in the Cascade Mountains and climbing successfully to the top of Mt. Rainier four times will forever be some of my fondest memories.

Left: A beautiful high-country rock garden of Indian paintbrush and lupine. The backdrop of Mt. Rainier and its glaciers are a reminder that this colorful display is ephemeral.

Above: A marmot eating lupine flowers.

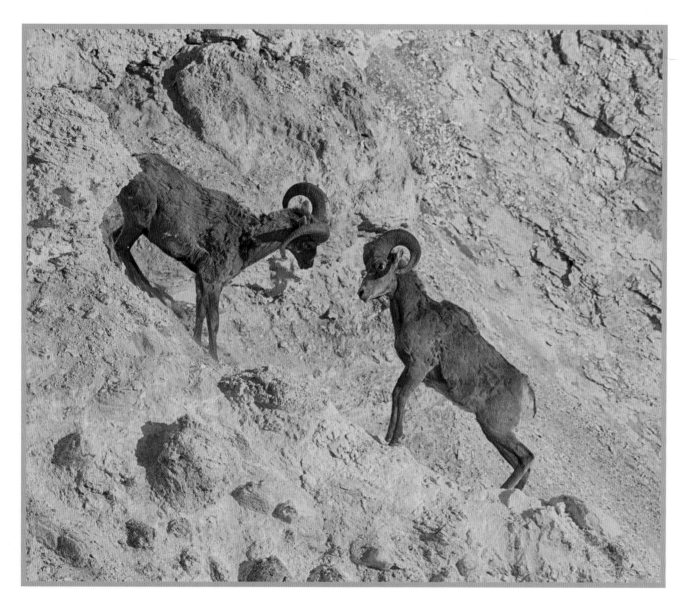

Above: Two Rocky Mountain bighorn sheep rams square off, preparing to butt heads in order to establish dominance as part of their late fall rut. The sheep have adapted to this annual battle; two layers of bone above their brains act as shock absorbers.

Right: This bighorn sheep ram's horns show evidence of battle. When the sheep's horns reach full curl, they may weigh as much as 40 pounds. Unlike antlers which are shed each year, a ram's horns are permanent and grow larger each year, especially when young.

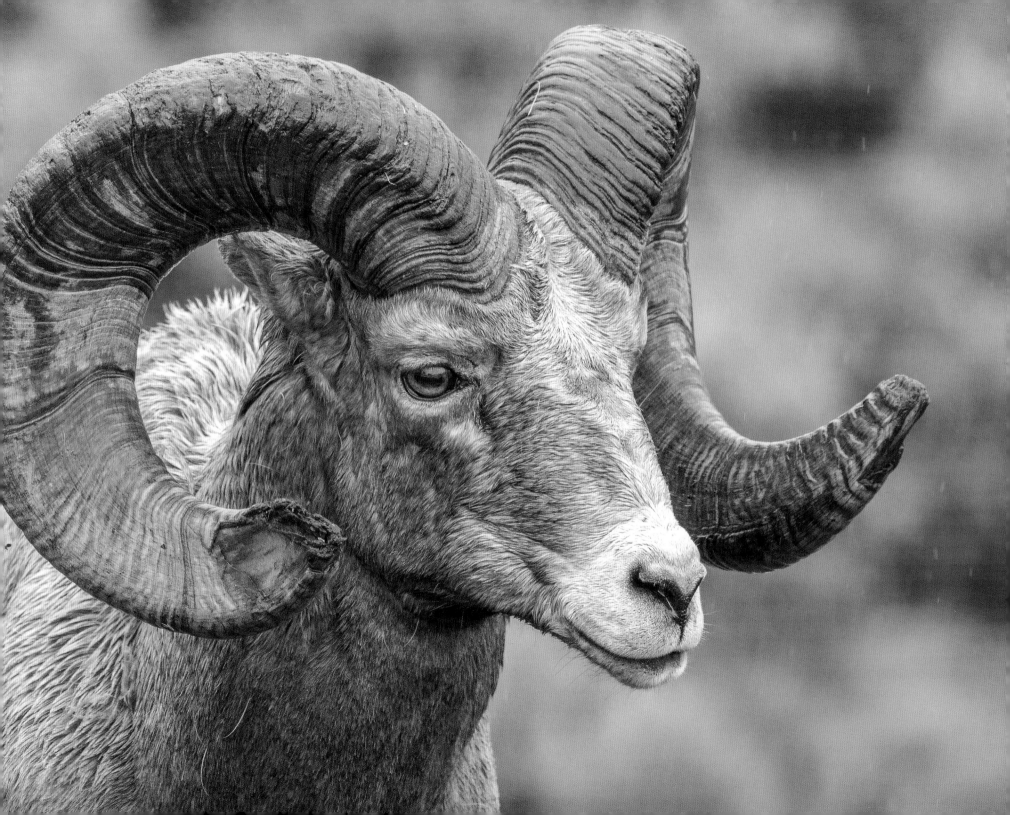

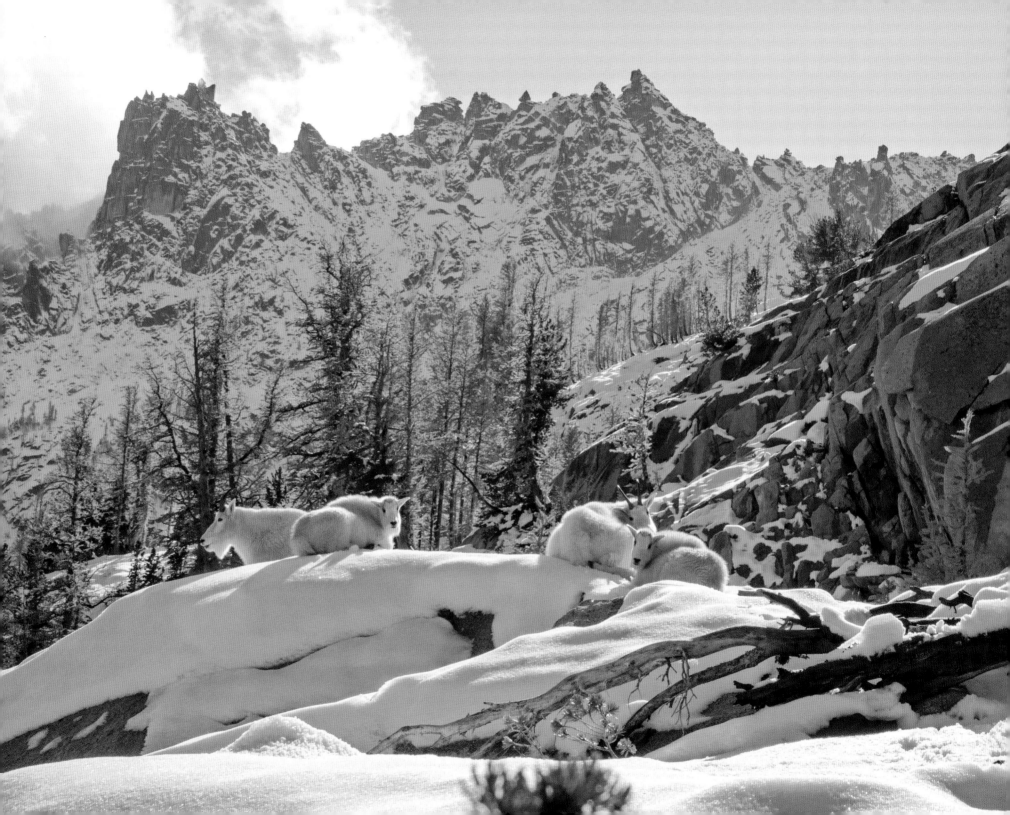

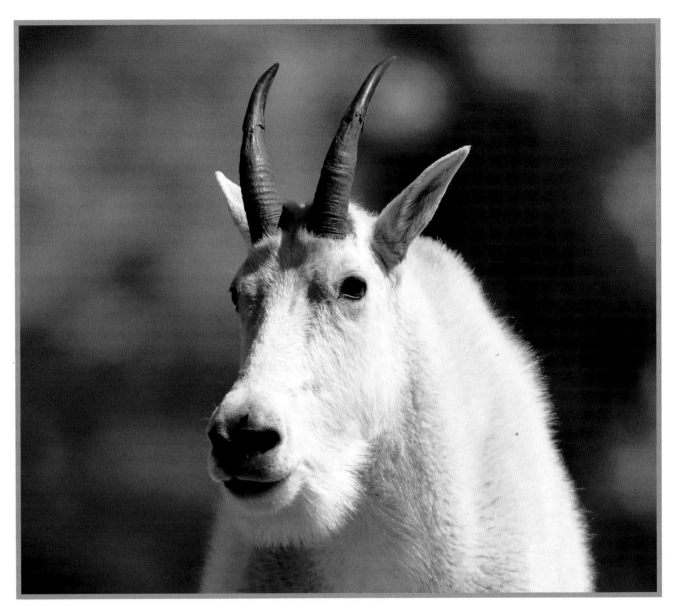

Left: Four mountain goats bask in late day October sun with the stunning backdrop of the Enchantments, part of the Alpine Lakes Wilderness in the Cascade Mountains of Washington State near Leavenworth.

Above: Mountain goat male or billy. These agile climbers have flexible pads in their hooves, allowing them to grab their rocky terrain. They can be seen in the Rocky Mountains and coastal ranges of the Pacific Northwest.

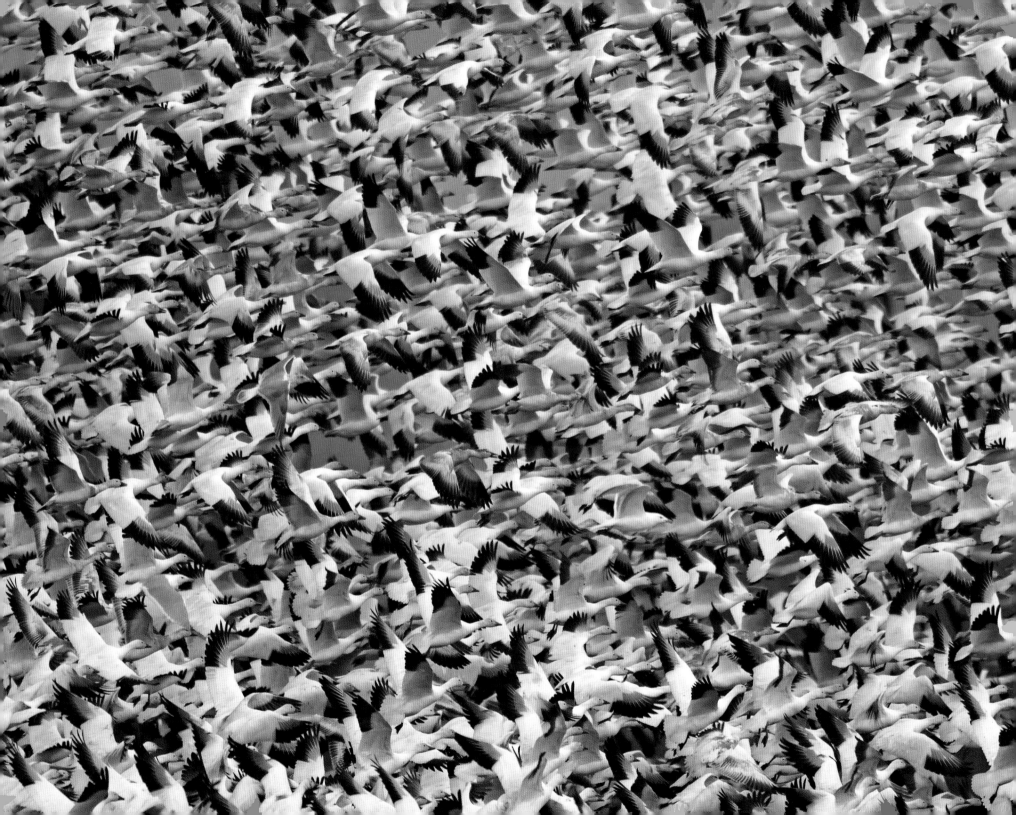

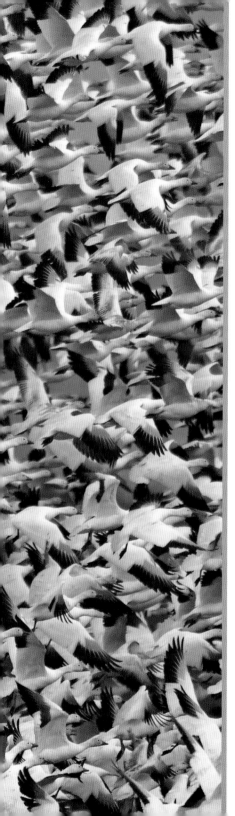

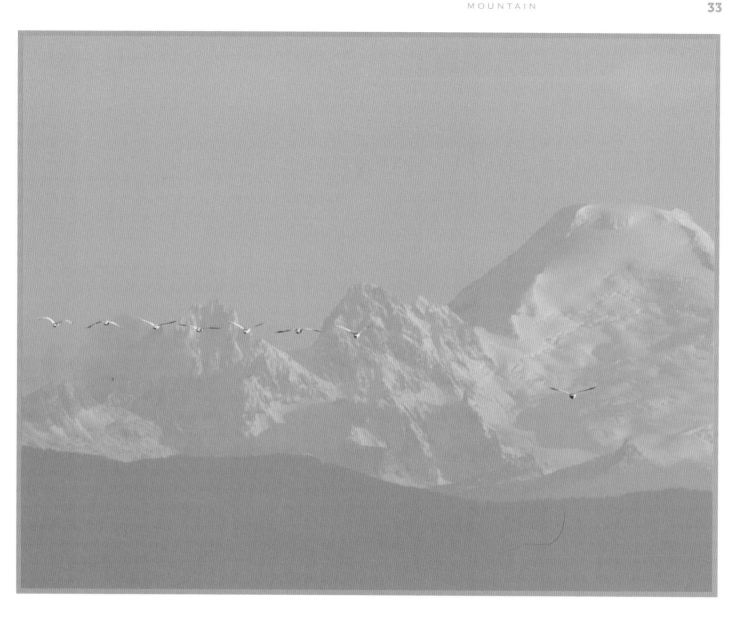

Left: Thousands of snow geese in winter. They migrate through parts of Washington, Oregon, Idaho, and Montana in spring and fall but also reside in parts of Washington and Oregon during the winter.

Above: Swans winter in the shadow of snow-capped Mt. Baker, Skagit Valley, Washington. Countless species of birds winter there making it a popular spot for wildlife photography.

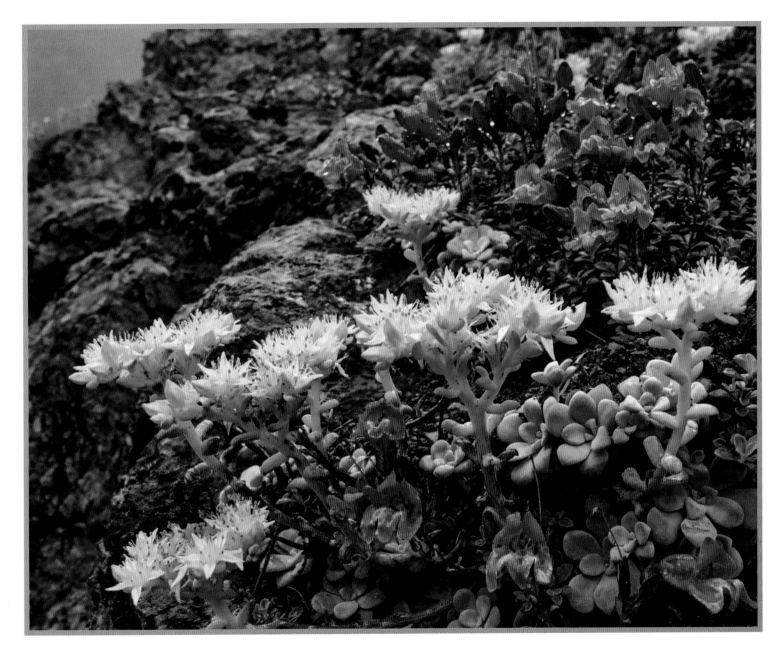

Above: Low-growing sedum and penstemon plants hug the rocks in high alpine country, providing a splash of color.

Right: Marmots can often be seen basking on a rock, soaking up high country sun. A large member of the squirrel family, it hibernates during the winter.

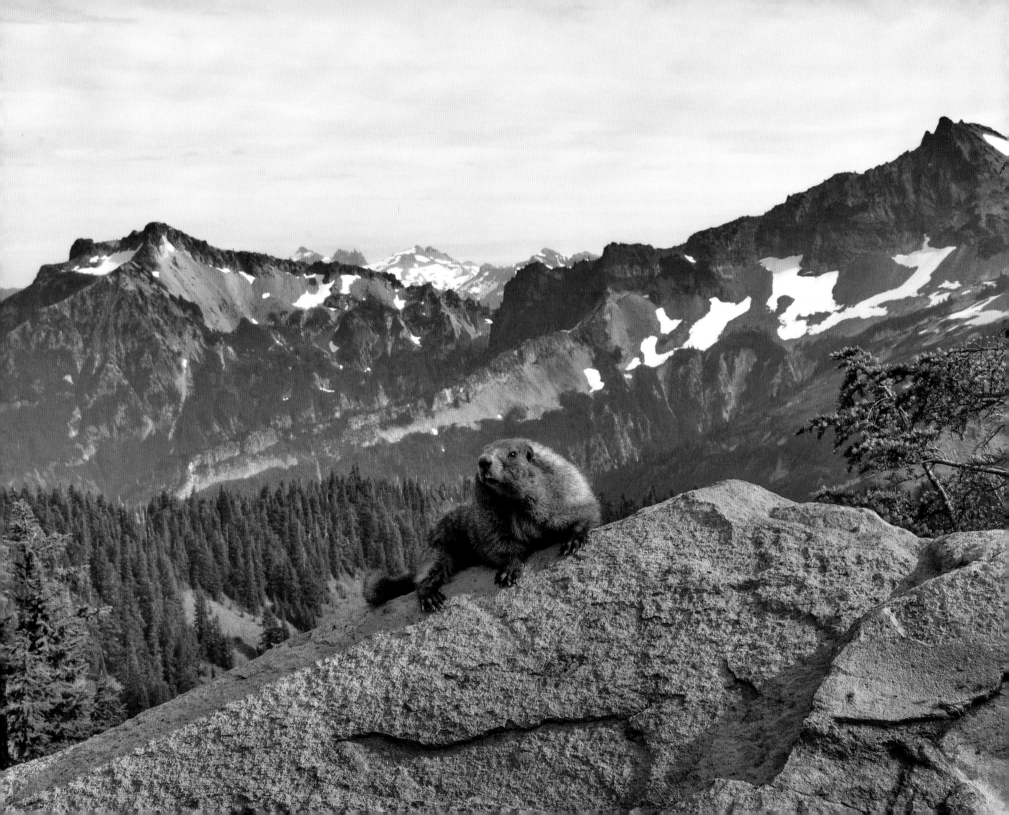

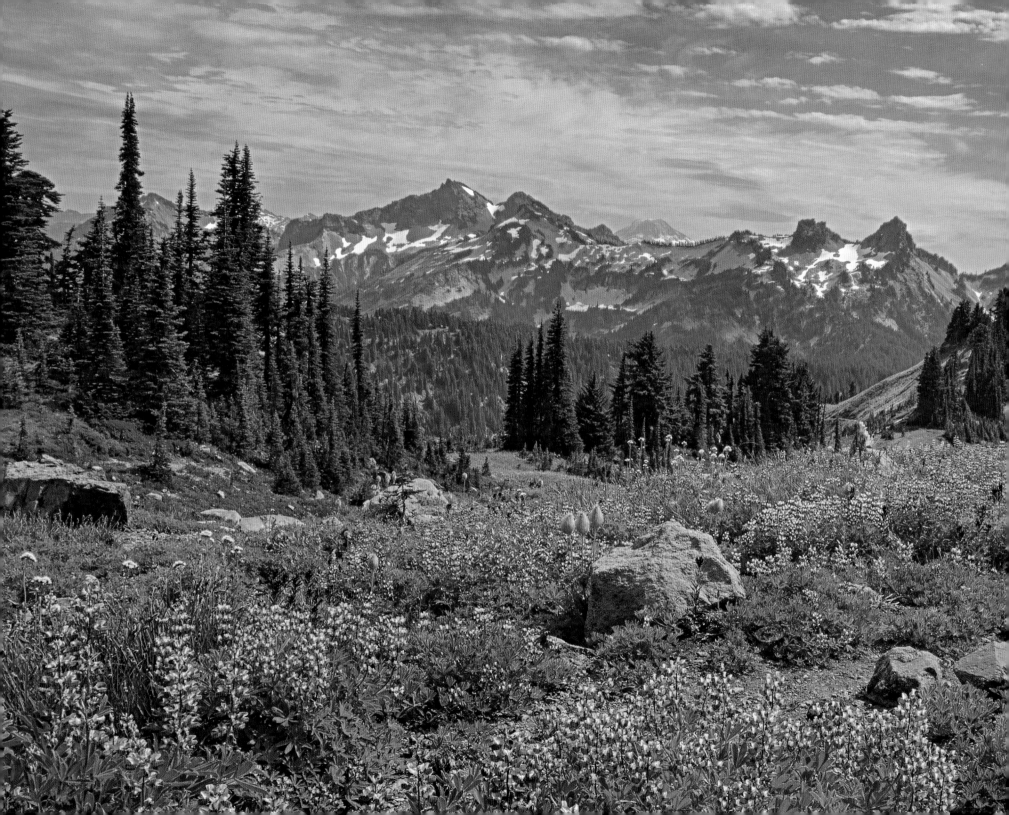

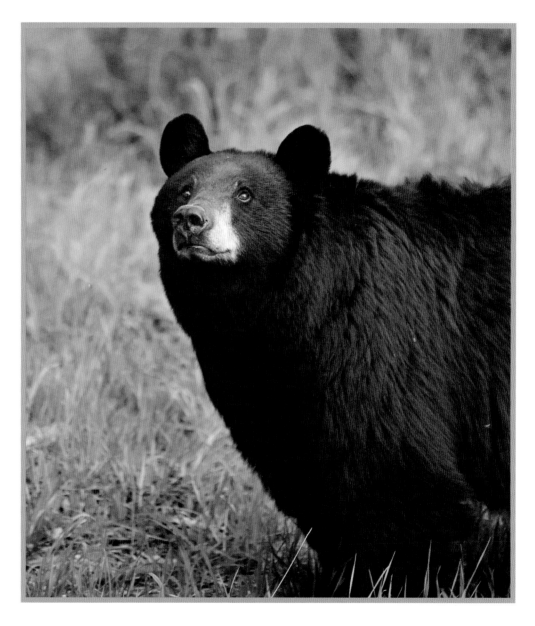

Left: In 1888, John Muir wrote about the wildflower bloom atop Mount Rainier: it is "the most luxuriant and the most extravagantly beautiful of all the alpine gardens I ever beheld in all my mountain-top wanderings."

Above: A protective and intent black bear mother just sent her cub up a tree in order to avoid danger. When the threat is past, she will call it down.

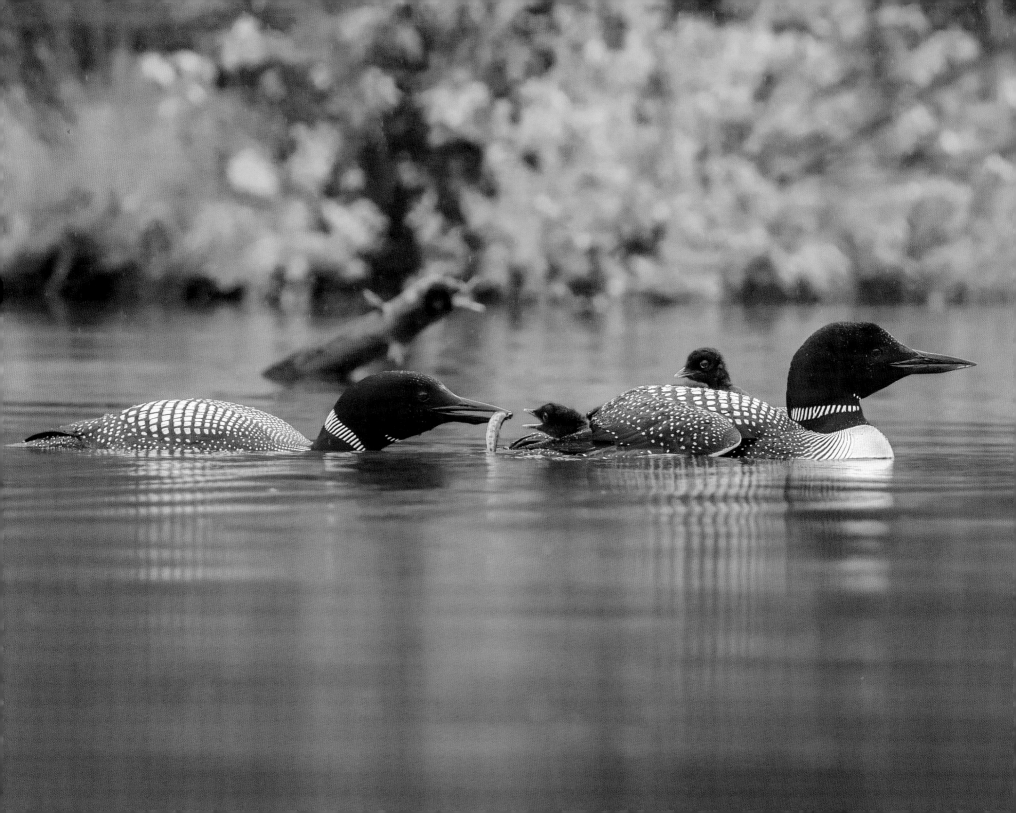

FRESH WATER

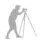

Fresh, clean water is an abundant resource in the Pacific Northwest. It cascades down waterfalls from the high mountains, nurtures wetlands, and creates rainforests and habitats that support an incredibly rich biodiversity of plants and animals. These habitats are key to a balanced and self-sustaining ecosystem. Some humans don't realize that people, too, are part of an ecosystem and play an important role in keeping these waters pristine. Fresh water results in a healthy, trickle-down effect for so many species, including our own.

I will never forget the time I spent with this family of loons alone in the remote British Columbia wilderness. The rain pelted the water and occasionally they voiced their extraordinary call that echoed across the lake for miles. If you have never heard the call of a loon in the wild, I would put it on the top of your bucket list.

Above: A male belted kingfisher splashing up out of the water. One of few bird species in North America where the female exhibits more color than the male. Look for a wide rust-colored band on the belly of the female.

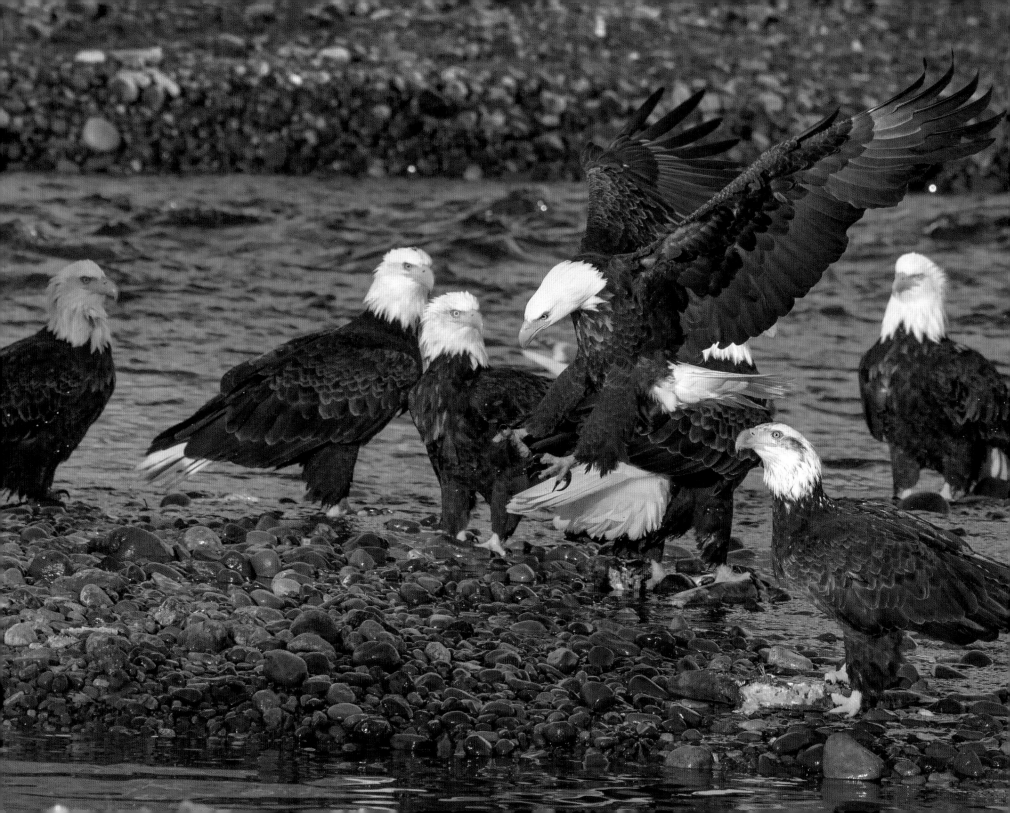

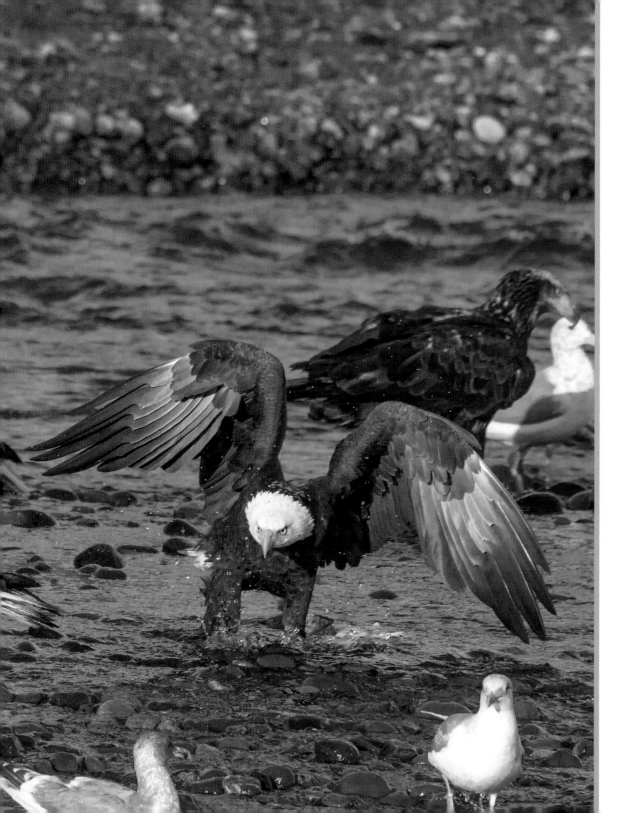

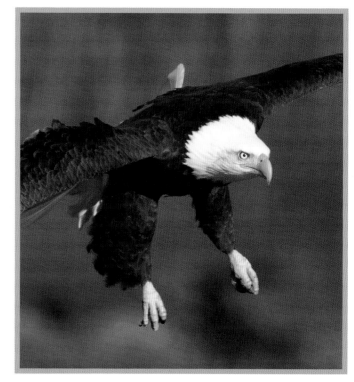

Left: Bald eagles congregate on the Fraser River, near Chilliwack, British Columbia, during the salmon runs in early January.

Above: An eagle flying in, ready to fight for territory and food.

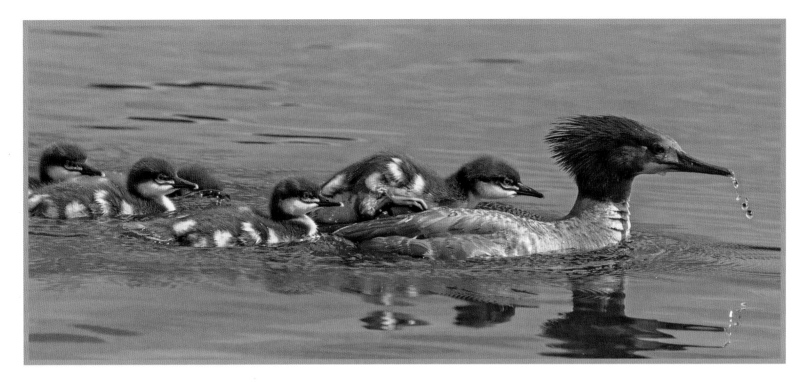

Above: Common merganser female swimming with young—one is hitching a ride.

Right: A pied-billed grebe in nest with two offspring sitting on top of her.

Far Right: American coot chicks have conspicuously orange-tipped ornamental plumes covering the front half of their body known as "chick ornaments" that eventually get bleached out after six days.

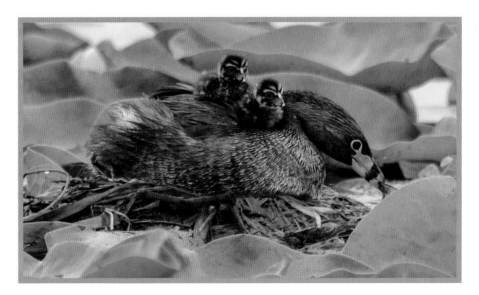

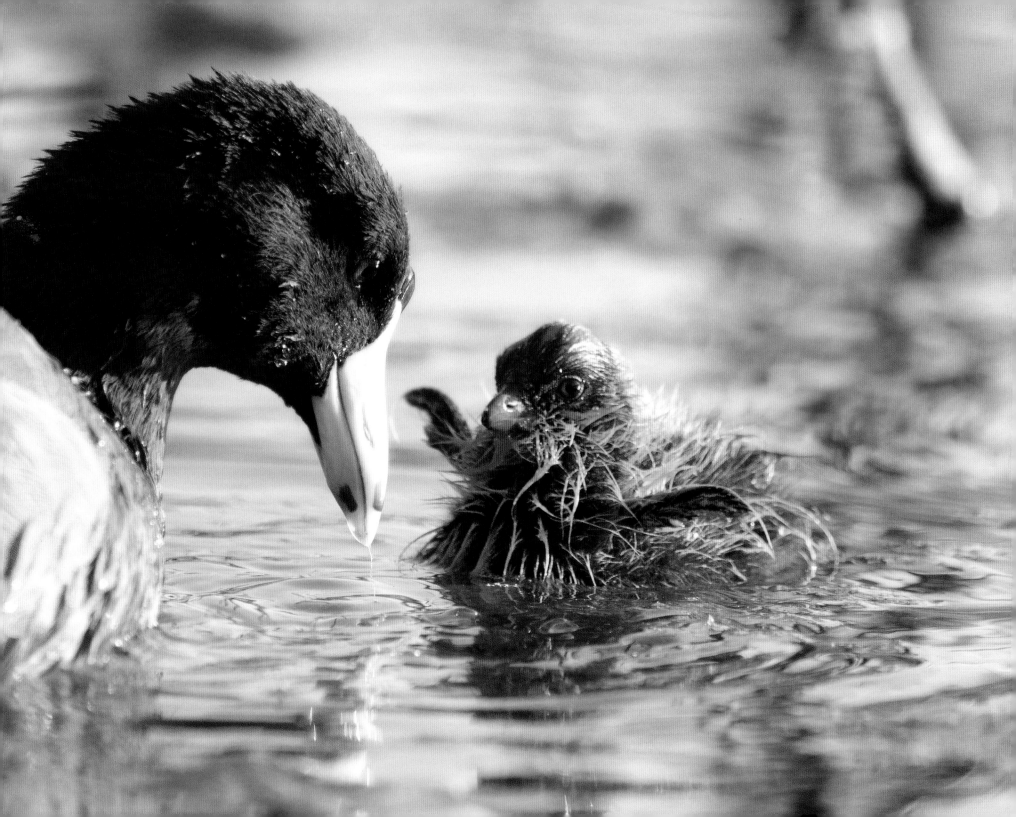

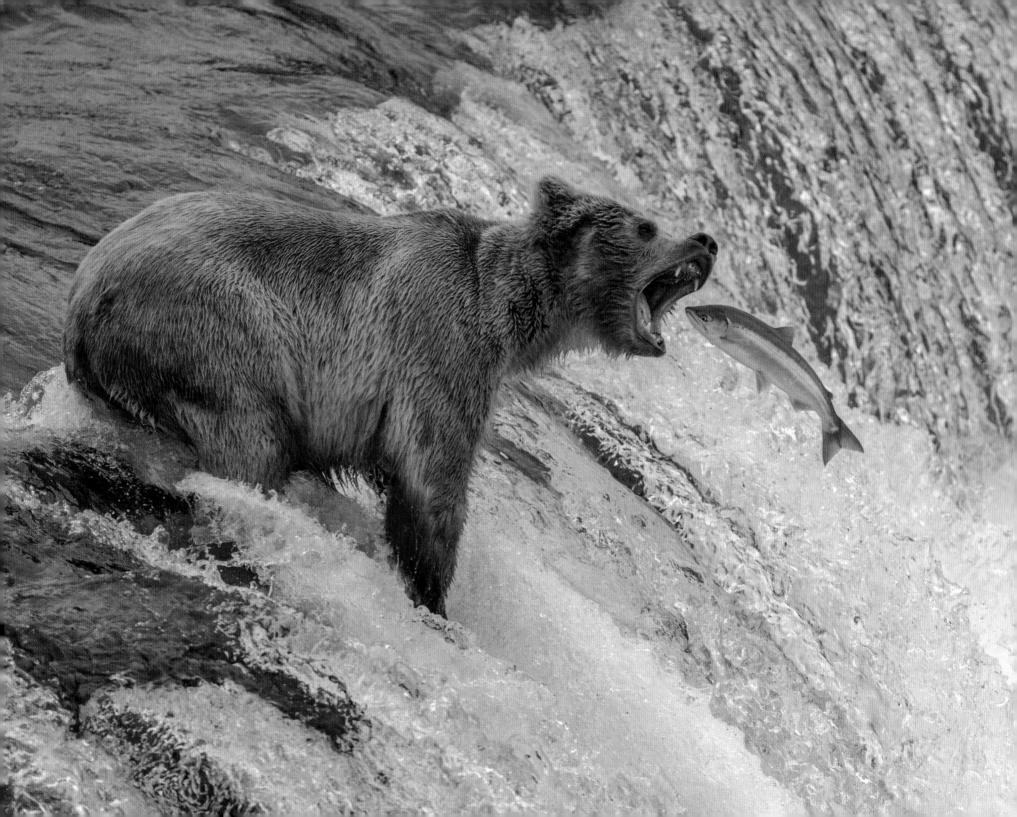

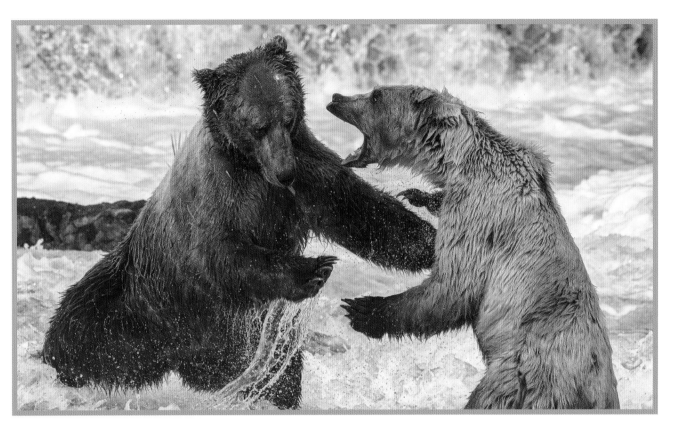

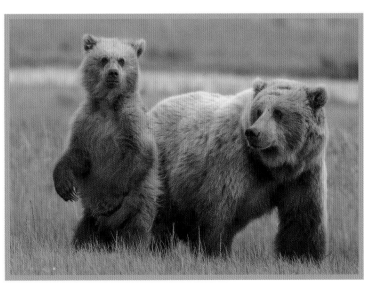

Above: Battle-wounded grizzly bears struggle for control over prime fishing territory at a waterfall in Katmai National Park in Alaska.

Left: Bears often stand up to gain a better vantage point and to scout for approaching danger.

Far Left: Visitors to Katmai National Park can witness one of nature's most exciting spectacles, grizzly bears hunting salmon. During the salmon run bears wait patiently on top of waterfalls to catch their next meal.

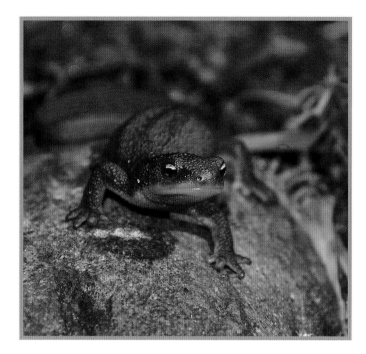

Above: The rough-skinned newt is a member of the salamander family that may grow to be nearly eight inches long. Its bumpy skin isn't slimy but don't be tempted to touch it; the oil in our skin is not only harmful to them, but they are very poisonous to humans if we ingest their skin secretions.

Right: Dahlia flower gardens, like this one in Snohomish County in Washington State, are a great place to find and photograph Pacific tree frogs. They thrive on a diet of small insects that the flowers attract.

Far Right: Sol Duc Falls in Olympic National Park. A short walk on the northwest side of the park takes you through old-growth lowland forests to experience one of the wettest places in the lower 48 states.

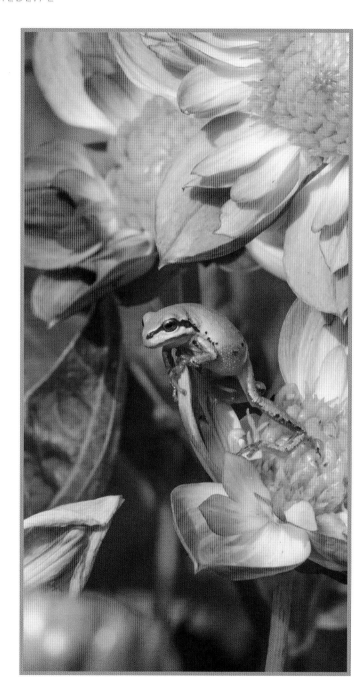

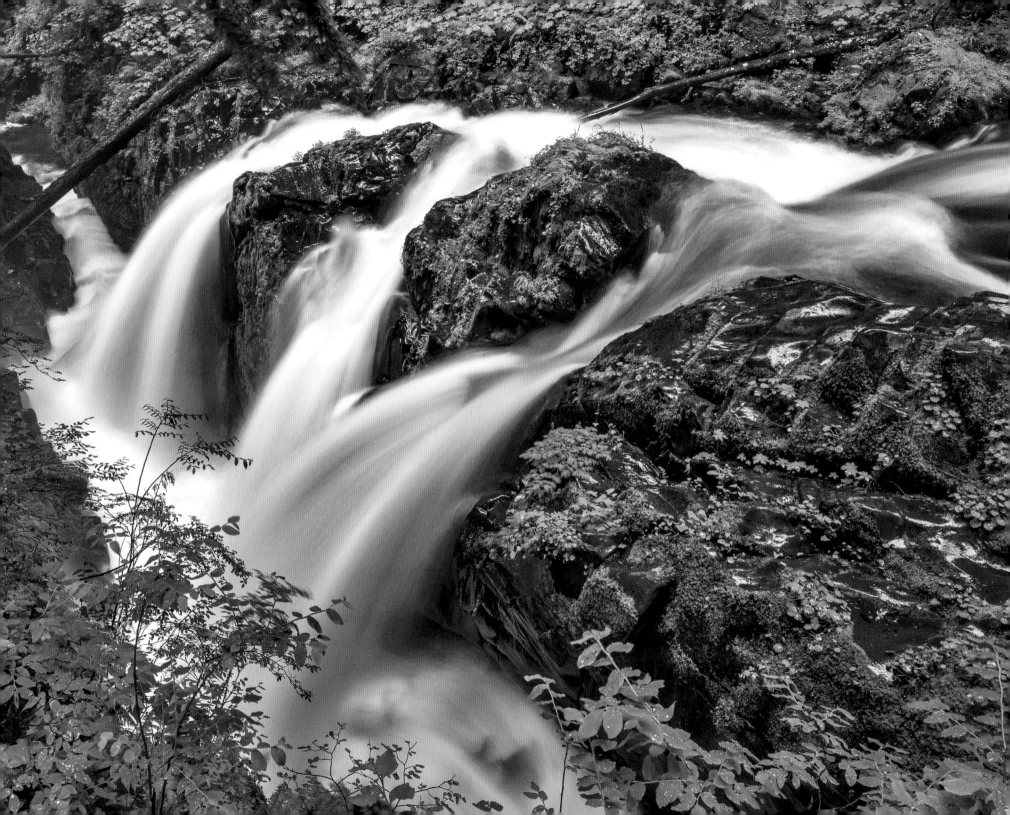

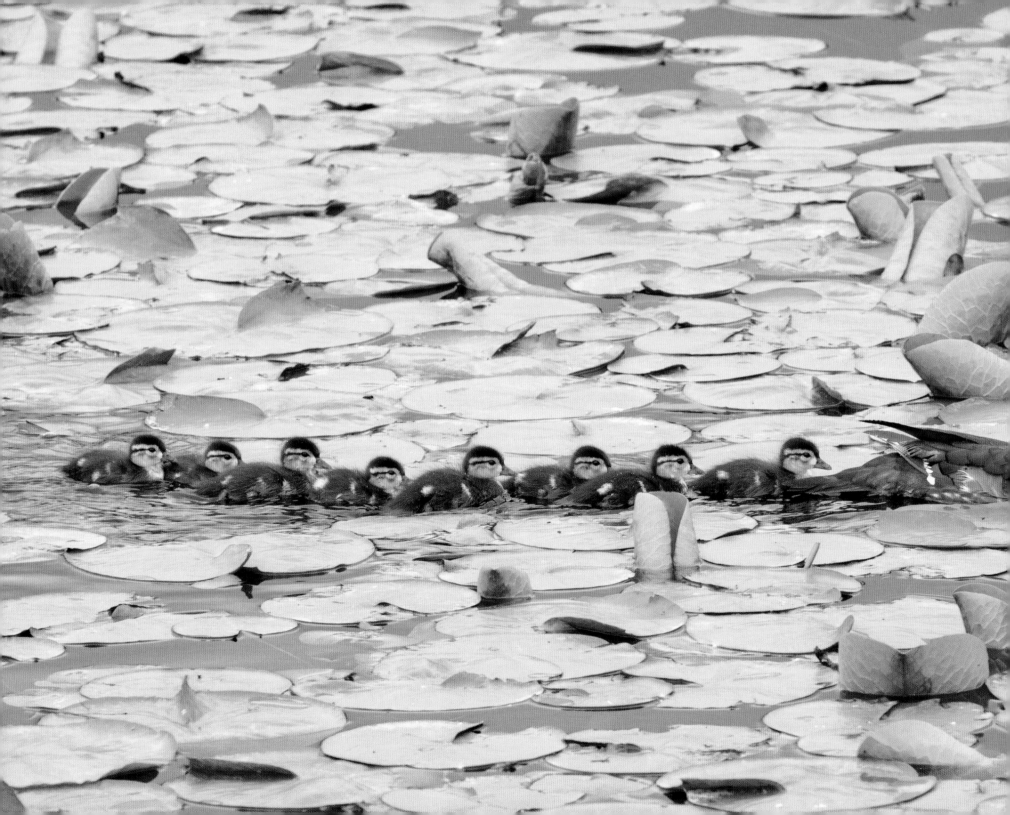

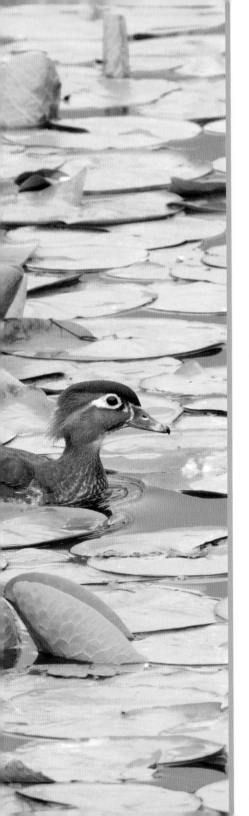

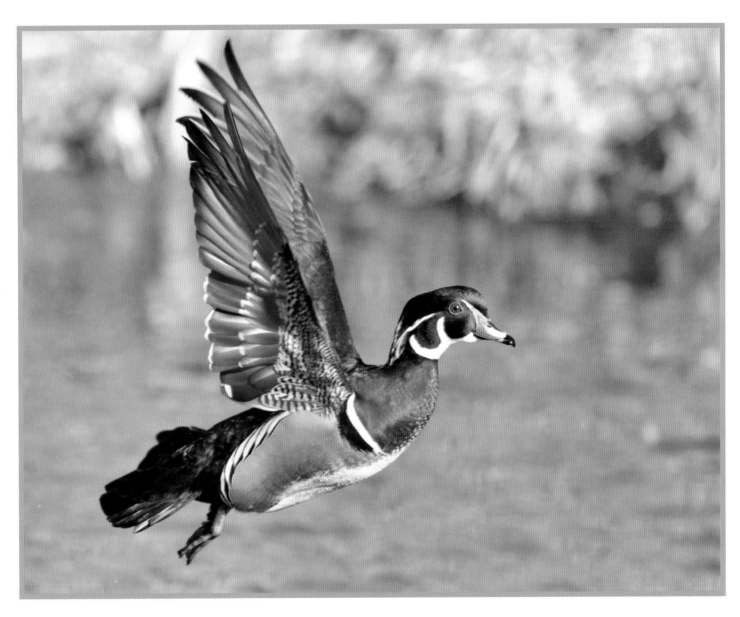

Left: Wood ducks are fairly common throughout the Pacific Northwest, but it's not every day that you'll see eight newly born ducklings swimming behind their mother.

Above: I consider the male wood duck the prettiest duck in North America. Its feathers were once prized for women's hats, jeopardizing their population. Even today it's important to think twice about popular trends in our culture that impact the environment negatively.

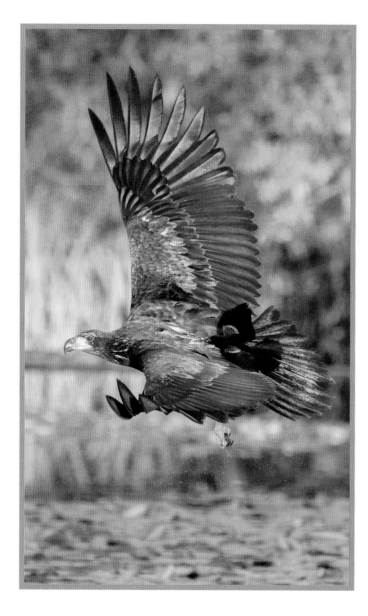

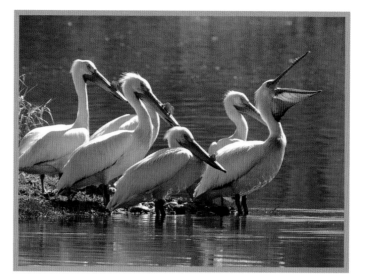

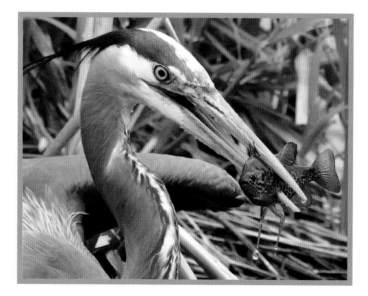

Above: Red-winged blackbirds commonly defend their nesting territories from birds as large as eagles, like the one pictured here.

Top Right: The Yakima River is a great place to photograph white pelicans in Washington State.

Bottom Right: After stalking its prey quietly, a great blue heron emerges from a lightning-fast head-first dunk into the water emerging with its catch.

Far Right: Sharp, long beaks allow great blue herons to spear fish which are their primary food source.

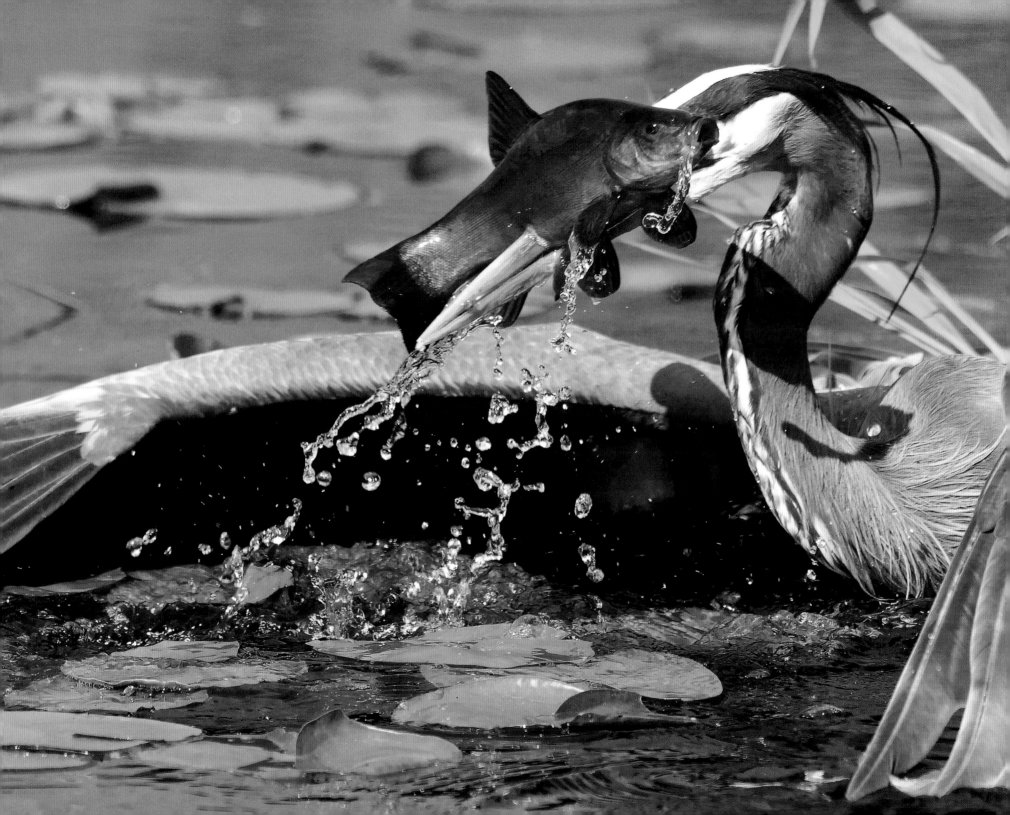

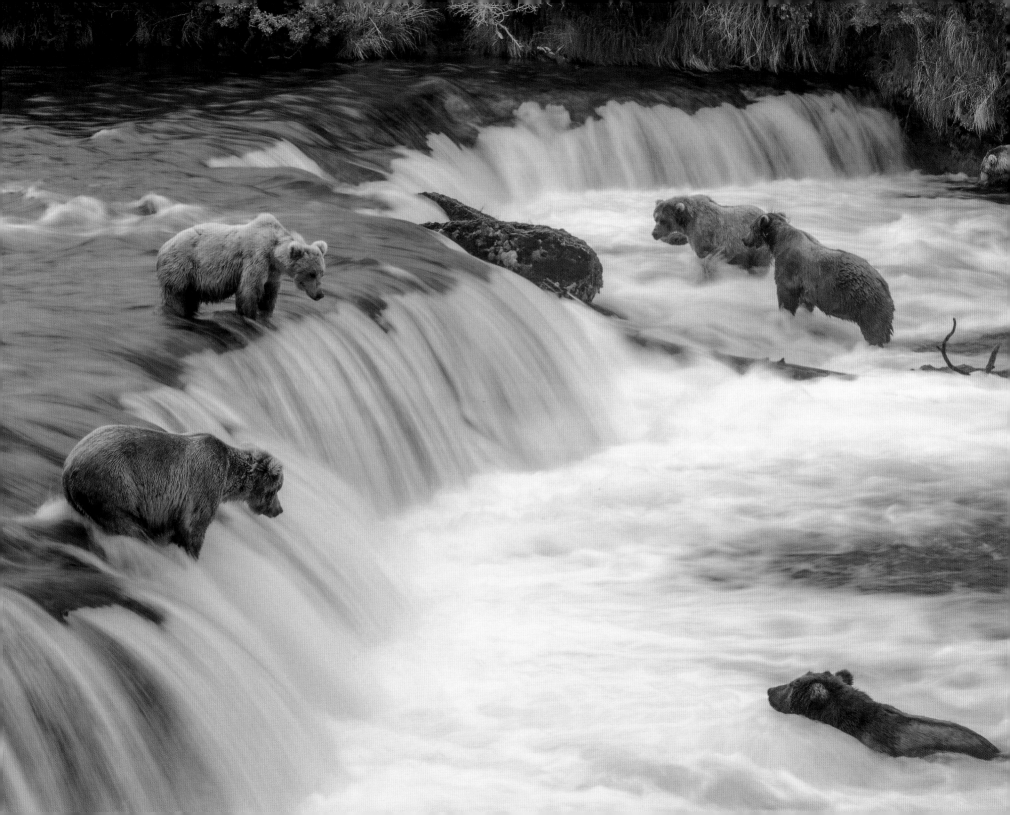

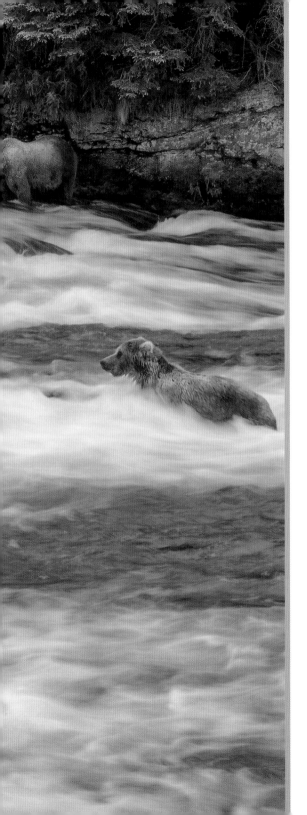

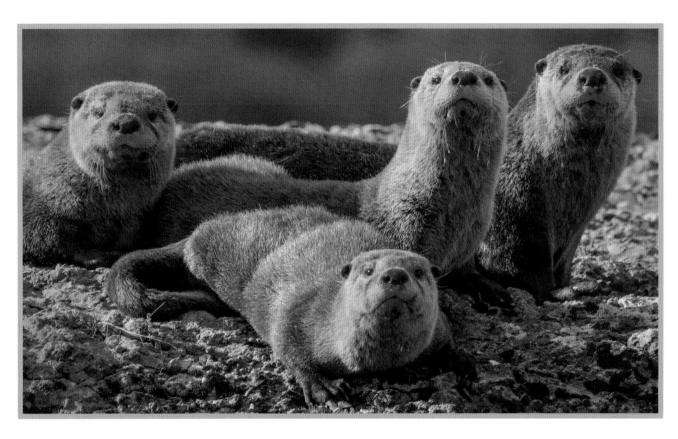

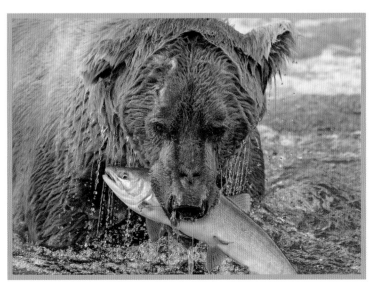

Above: A family of river otters check their surroundings from a rocky outcrop on the river before settling down for an afternoon nap.

Left: A successful dive produces an unlucky sockeye salmon. At this location I watched one bear consume 18 salmon in 45 minutes.

Far Left: Brown bears wait patiently for the next wave of sockeye salmon to run upstream at Brooks Falls in Katmai National Park. I shot this image at 1/10th of a second to produce motion blur on the water. I waited patiently for the bears to stand perfectly still so that their image would be sharp. At slow shutter speeds it is beneficial to use a tripod with a remote trigger.

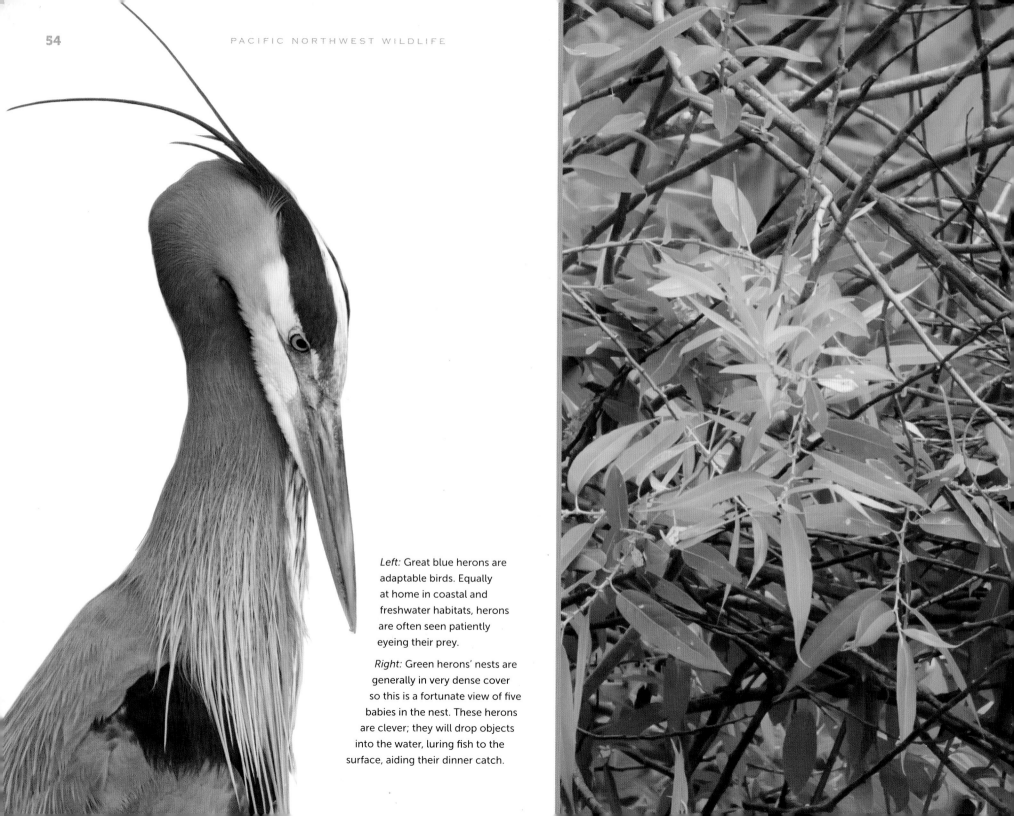

Left: Great blue herons are adaptable birds. Equally at home in coastal and freshwater habitats, herons are often seen patiently eyeing their prey.

Right: Green herons' nests are generally in very dense cover so this is a fortunate view of five babies in the nest. These herons are clever; they will drop objects into the water, luring fish to the surface, aiding their dinner catch.

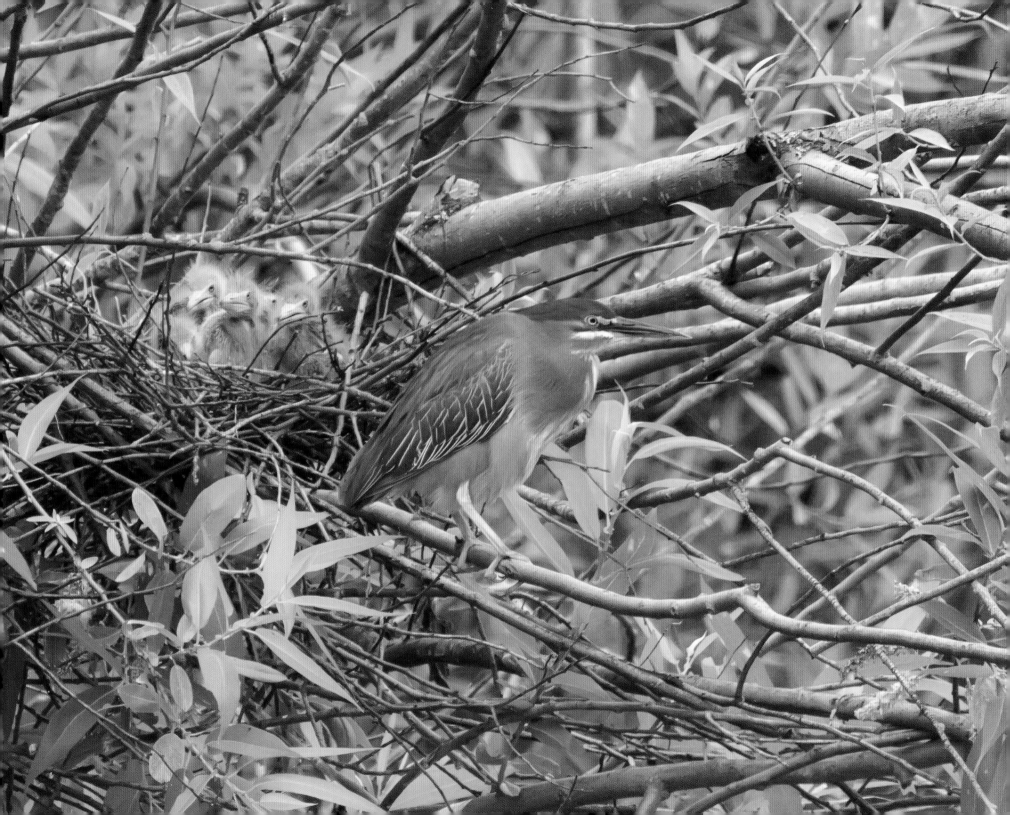

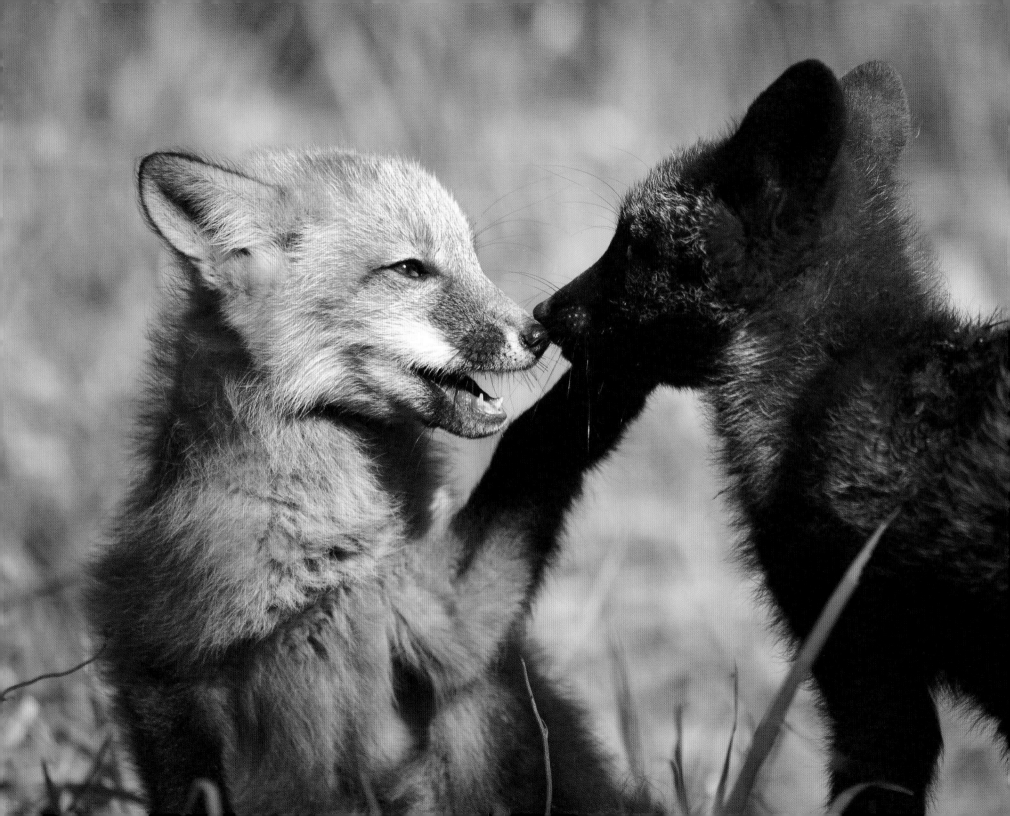

GRASSLAND

"Grasslands challenge our senses, calling us to open our eyes to impossibly broad horizons and then, in the very next breath, to focus on some impossibly tiny critter hidden in the grass."

◦◦ Candace Savage

About a quarter of the earth is covered in grasslands. These open areas may not seem as important as forests to revere and protect, but in fact, they are crucial habitats for many wildlife species. Only a small fraction of grasslands are preserved.

Open, treeless areas support grass and forbs that are home to many species that raptors, owls, snakes, wolves, coyotes, and many other predators prey on. Meadows or clearings in the mountains or forests of the Pacific Northwest provide forage for herbivores like mice, elk, deer, pronghorn, and many other species. Others—badgers, fox, sandhill cranes, and even owls, to include a few, use them for denning and nesting.

Left: Two red fox kits. While young animals are being cared for by their parents, and before they have to find their own food, they explore and play.

Above: A juvenile sharp-shinned hawk.

57

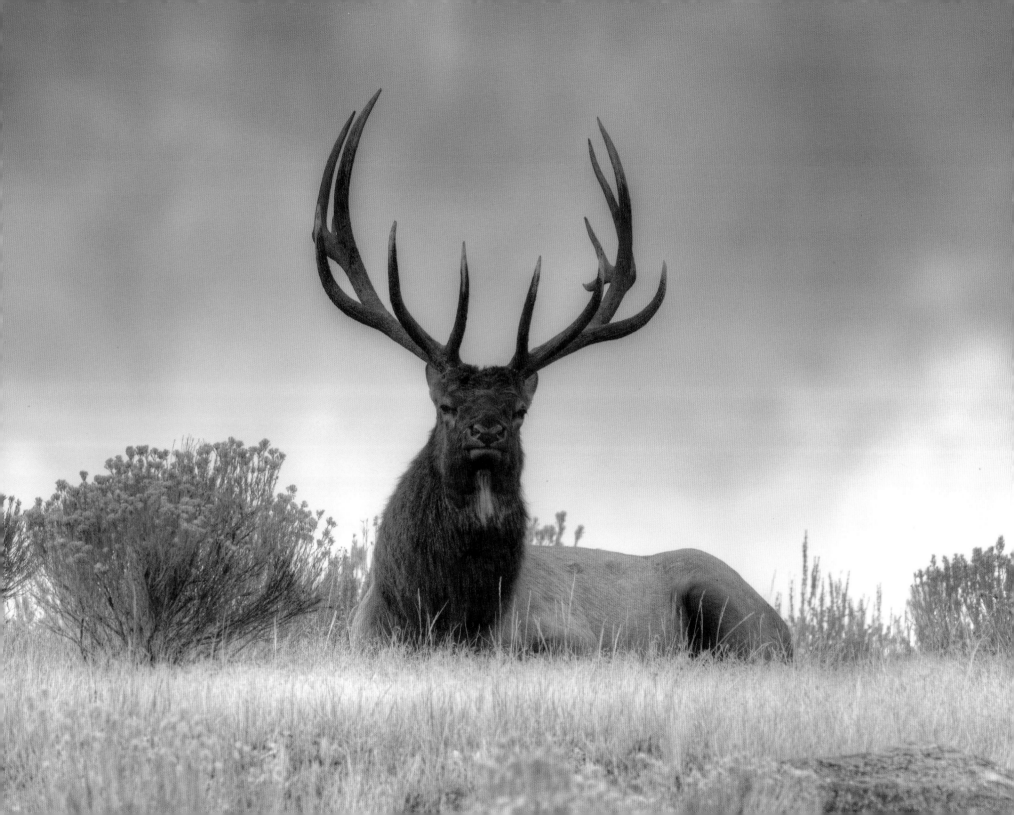

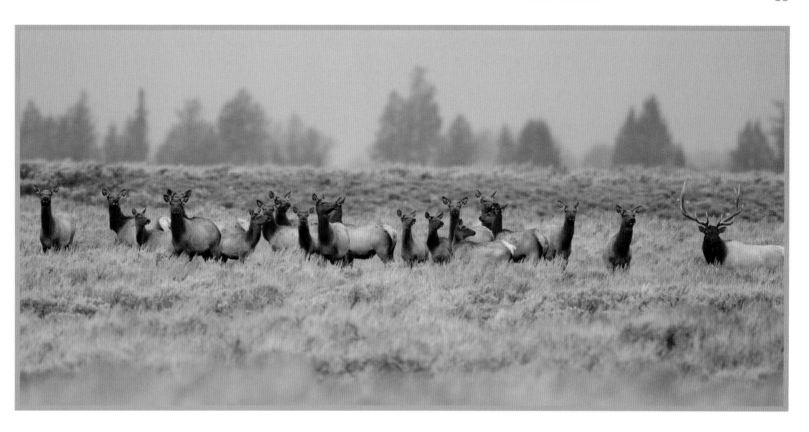

Left: A Rocky Mountain bull elk in Yellowstone National Park. The Greater Yellowstone Ecosystem supports about 30,000 elk.

Above: A bull elk, right, guarding his harem of cows during the fall rut in Grand Teton National Park.

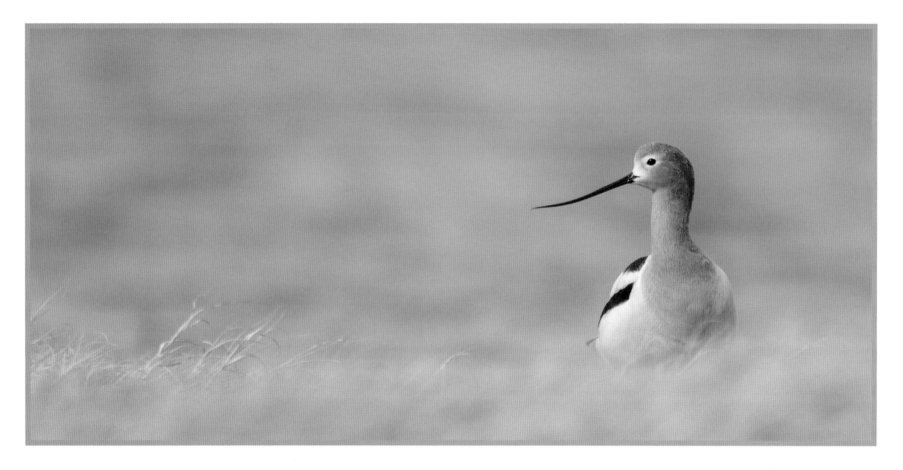

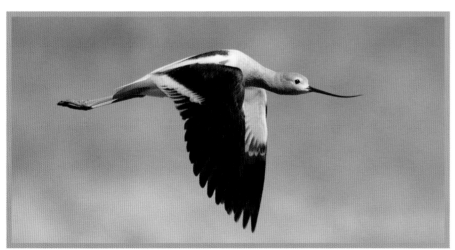

Above and Left: American avocet, a wading bird that is fairly common yet is an exciting find in wet habitats throughout the western half of the United States. It feeds by sweeping its bill back and forth through the water.

Right: As black-necked stilts fly through the air, their reflections grace the water below. These birds breed in wet habitats of eastern Washington, southern Oregon and Idaho.

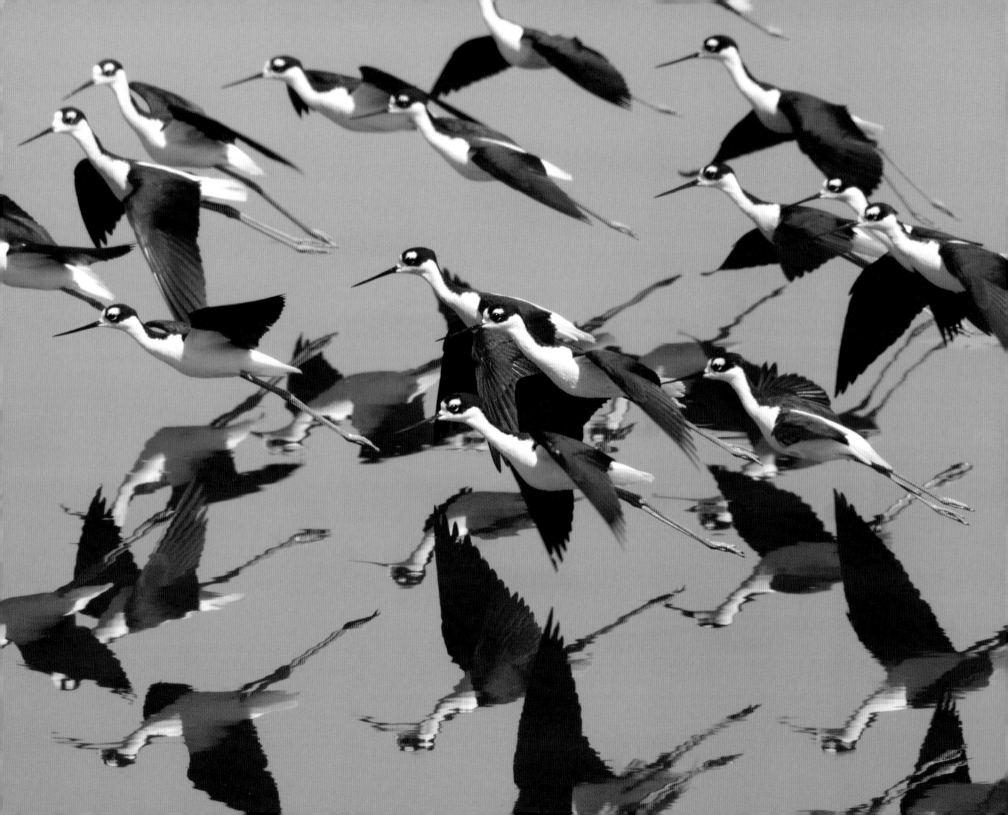

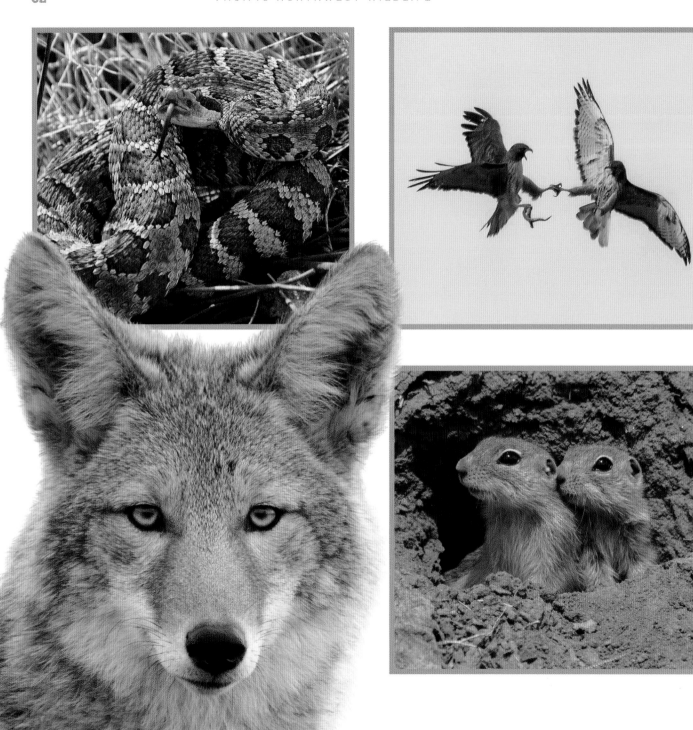

Far Left Top: Western rattlesnake coiled and ready to strike.

Left Top: Red-tailed hawks engage in aerial combat. The winner may enjoy the rattlesnake as a delectable meal.

Far Left Bottom: A coyote.

Left Bottom: Two ground squirrels at the entrance to their burrow.

Right: A fox checks for danger before cuddling up for a morning nap.

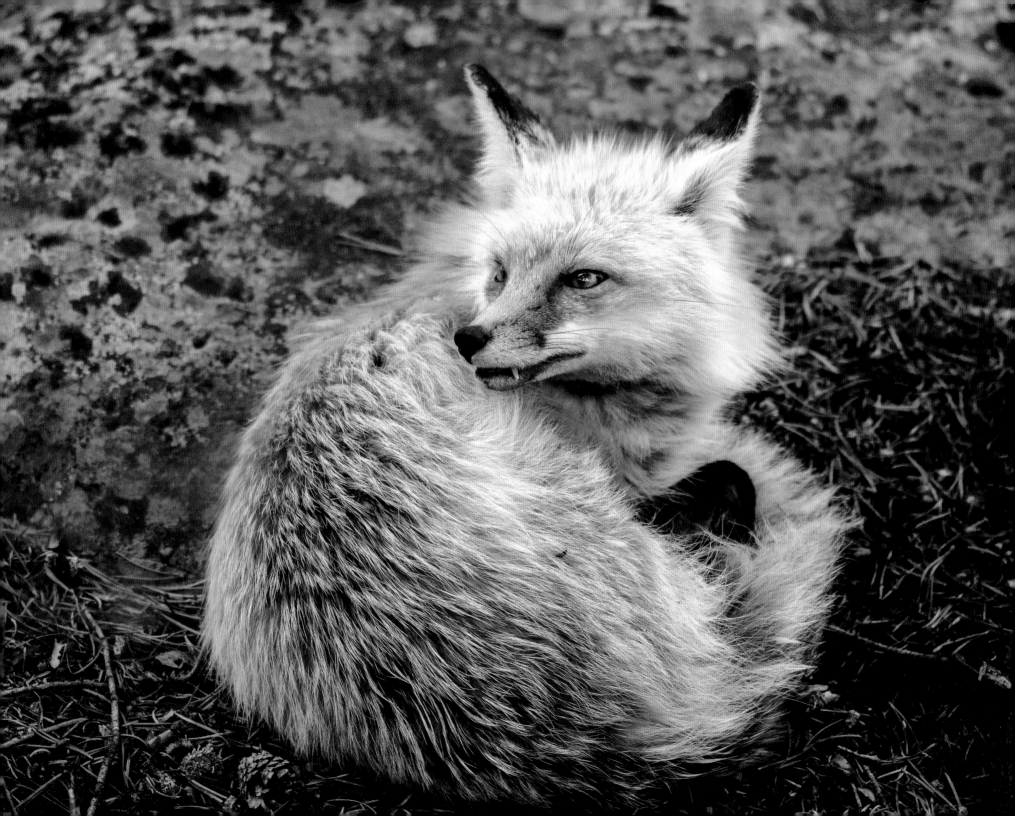

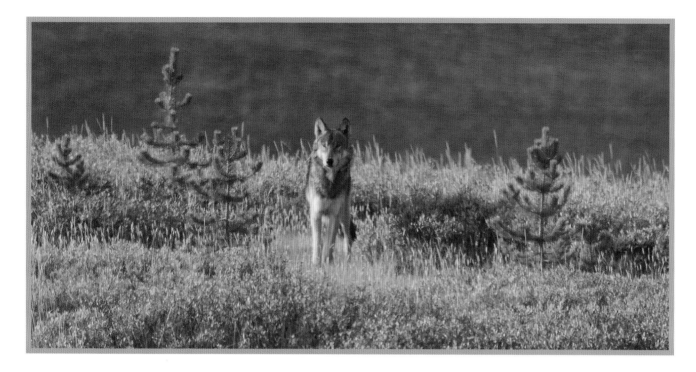

Above: A gray wolf.

Right: Grizzly bear and gray wolf. These two species have an interesting relationship. A wolf pack makes a kill—usually an older elk—and then, if bears are not hibernating, they may have to give it up to a grizzly, unless there are enough wolves to chase the bear away.

Far Right: A wolf scans the landscape in search of prey.

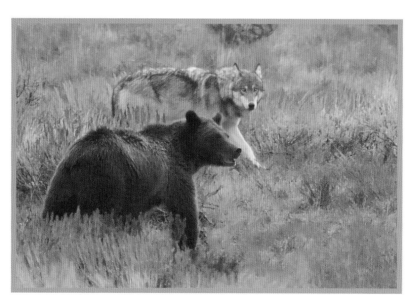

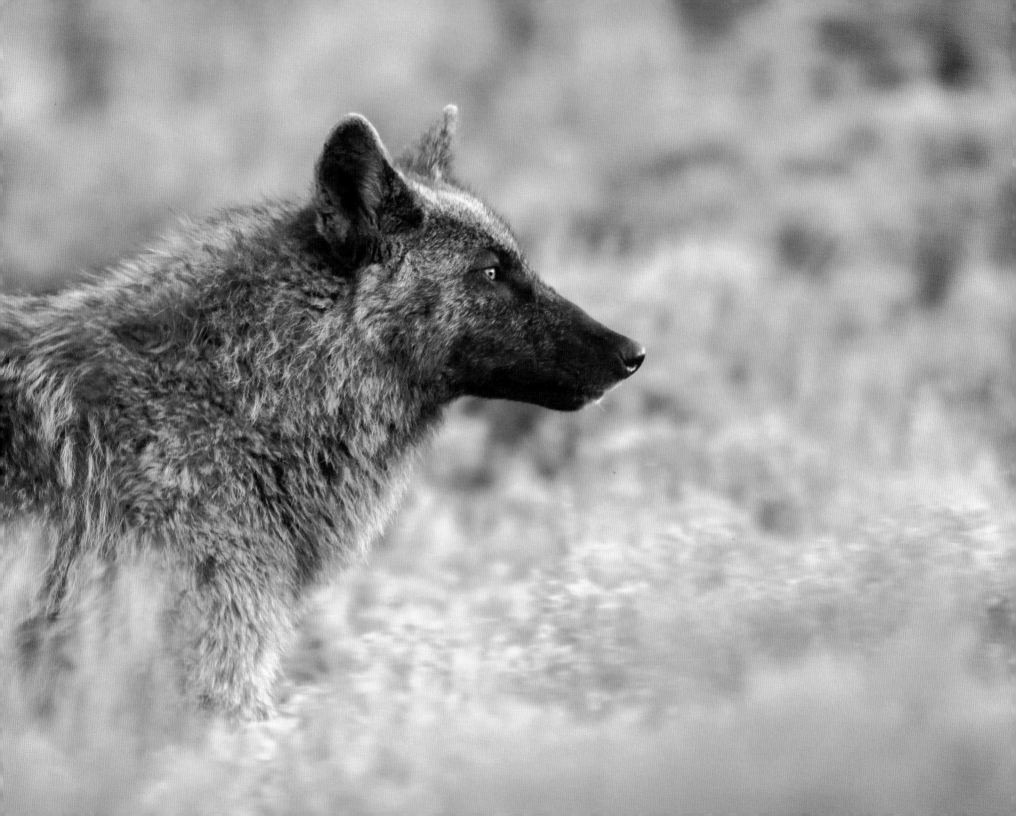

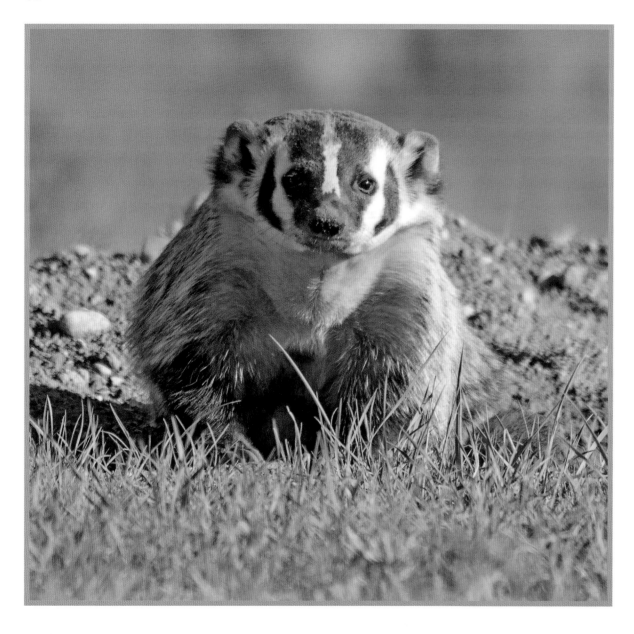

Above: The badger is one of the fiercest animals in the Pacific Northwest and sometimes chases off predators much larger then itself. They are generally nocturnal.

Right: Pronghorn are the fastest animal in the Western Hemisphere. Their 60 miles per hour speed may have evolved because they live in open country and, in order to survive, needed to be faster than their predators.

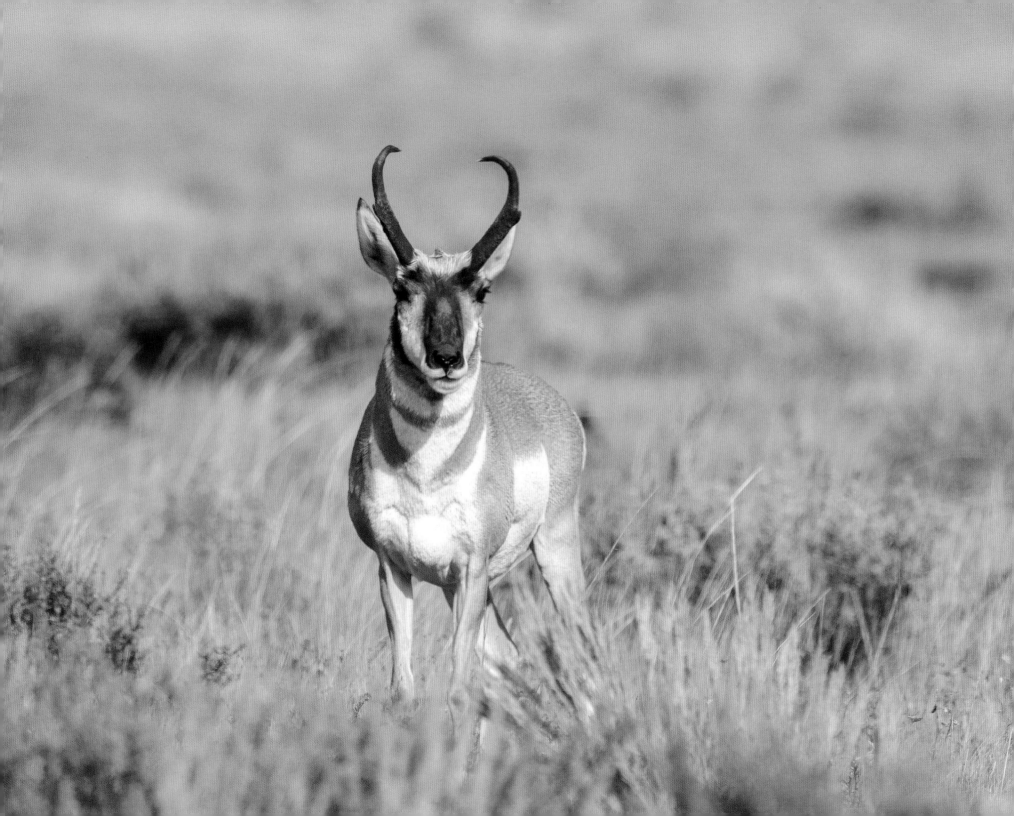

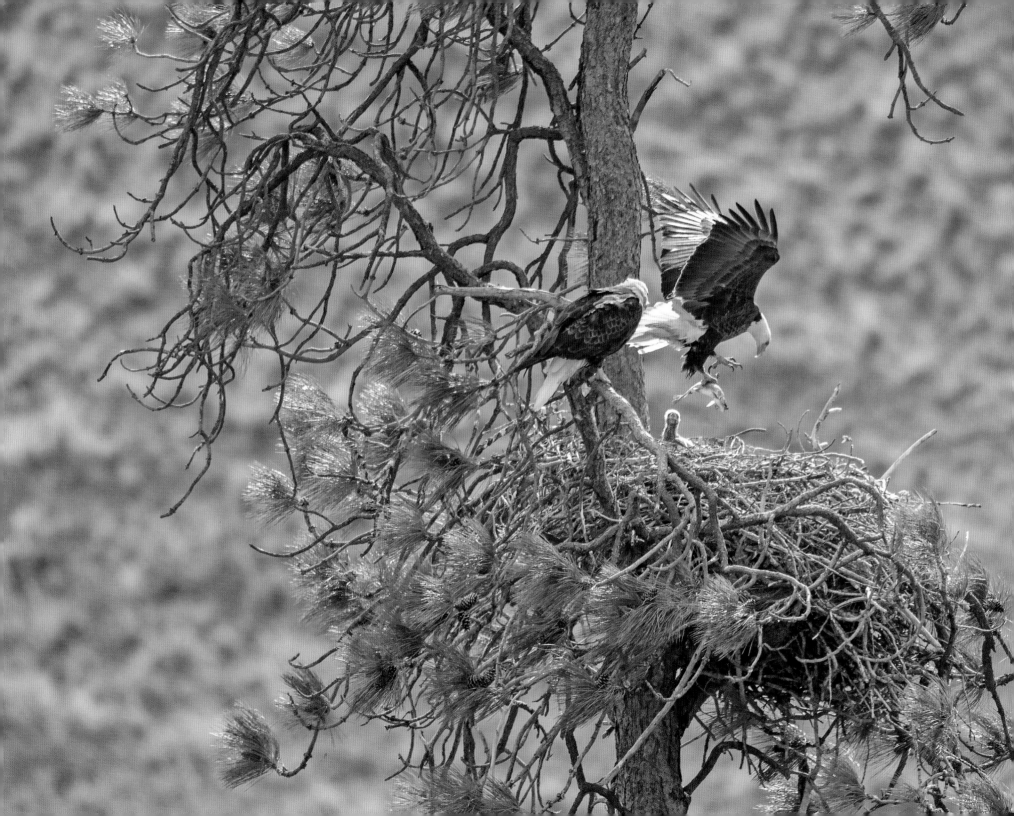

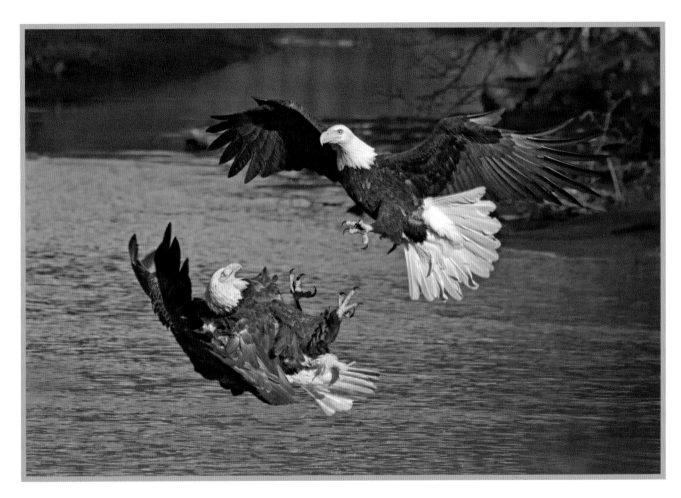

Left: Adult bald eagle bringing home a trout to its family in Washington's Yakima Canyon. The Yakima River teems with fish making it a great place for eagles to nest.

Above: Bald eagles in a dramatic, mid-air territorial battle.

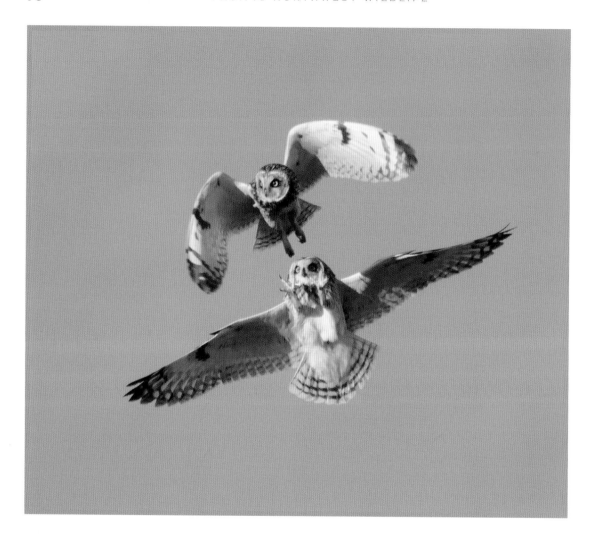

Above: Short-eared owls commonly engage in territorial mid-air battles.

Right: Great-horned owl family in their nest. They live in widely varied habitats—woodlands and forests of varying type—but they also utilize nearby open country to hunt.

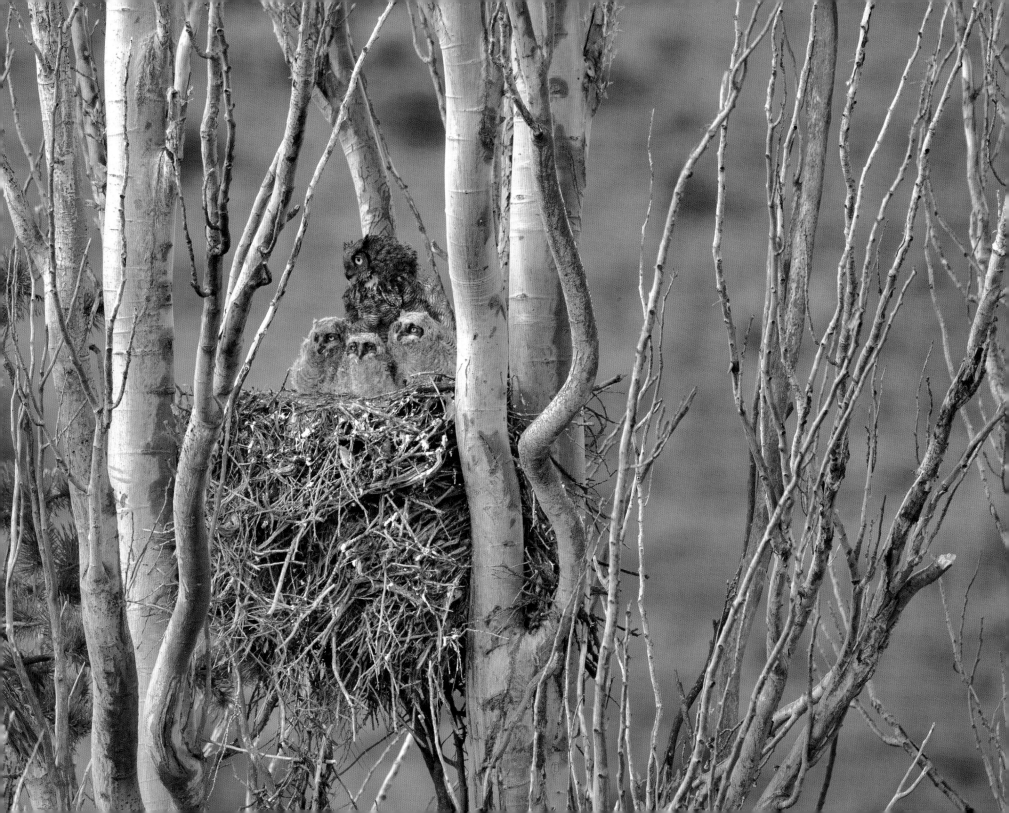

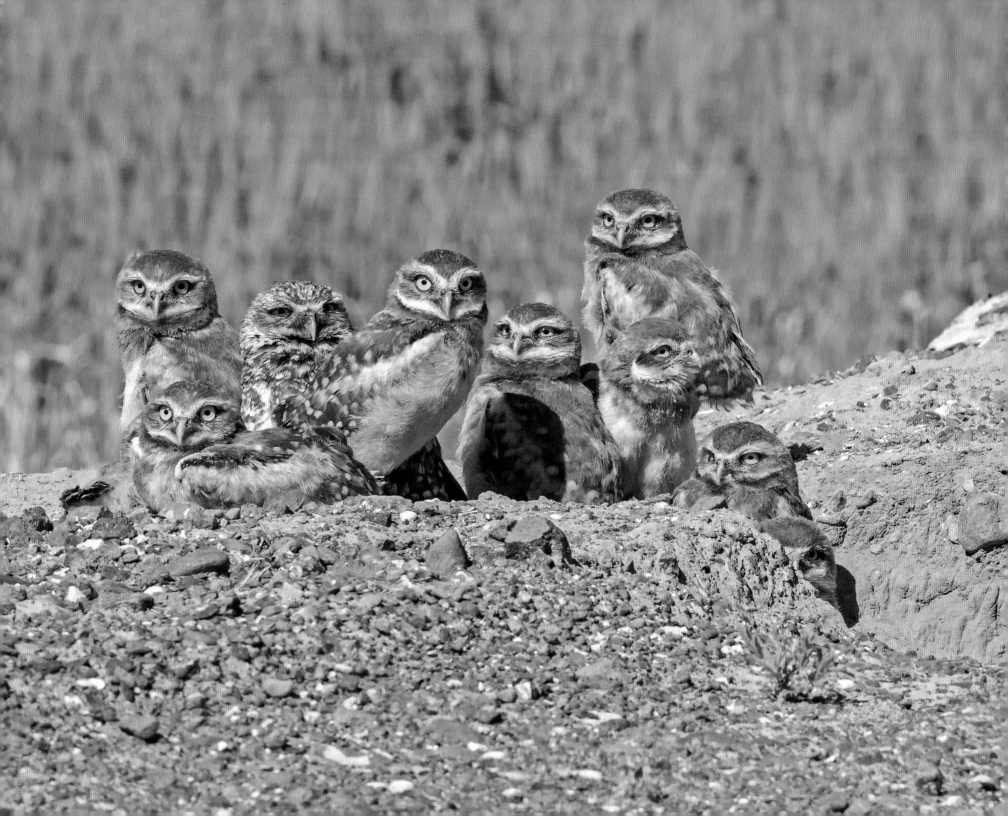

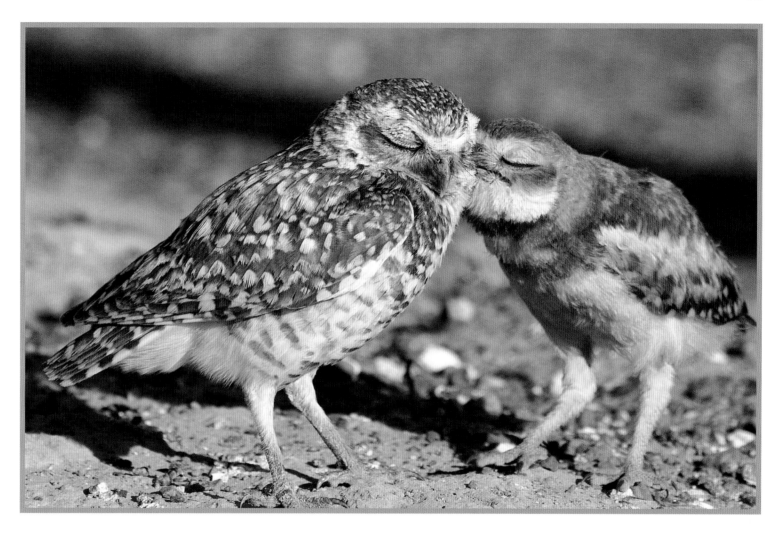

Above: Burrowing owl and offspring in a "touching" moment.

Left: A parliament of burrowing owls, a small species of owl that nests underground and inhabits open areas with short grass. Adult owls collect mammal dung and scatter it around the edge of their nest to attract dung beetles—a quick food source for their owlets.

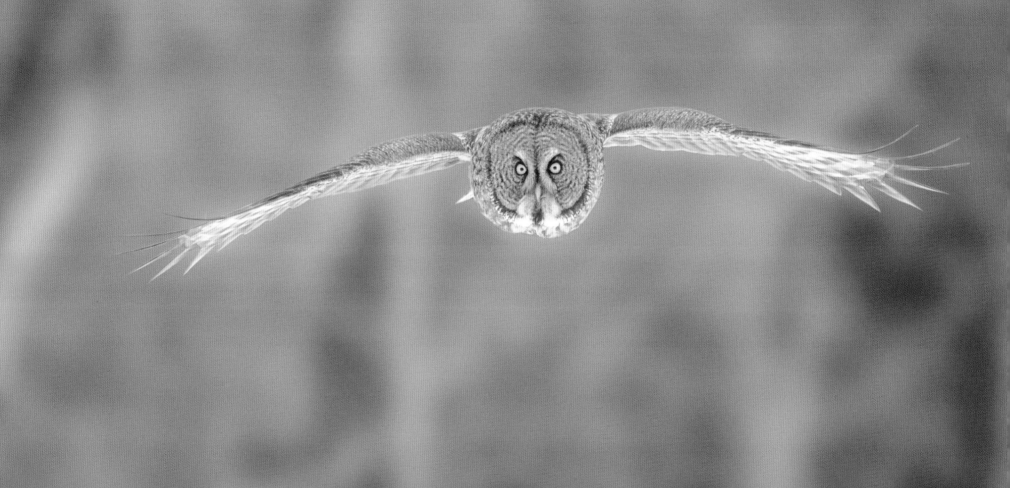

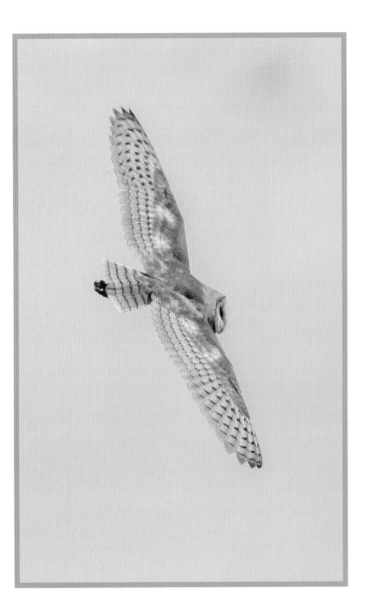

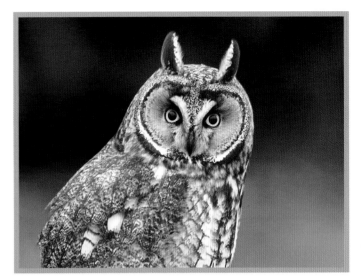

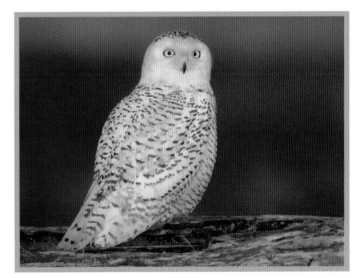

Left: A stealthy great gray owl zeros in on its prey. I've spent countless hours of research and scouting owl habitats, aiding my success of photographing 12 species of owls in the Pacific Northwest.

Above Left: Barn owl.

Top Right: Long-eared owl.

Bottom Right: Snowy owl.

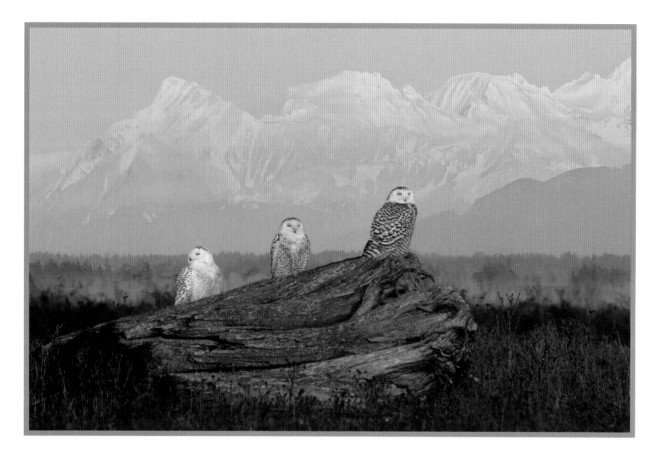

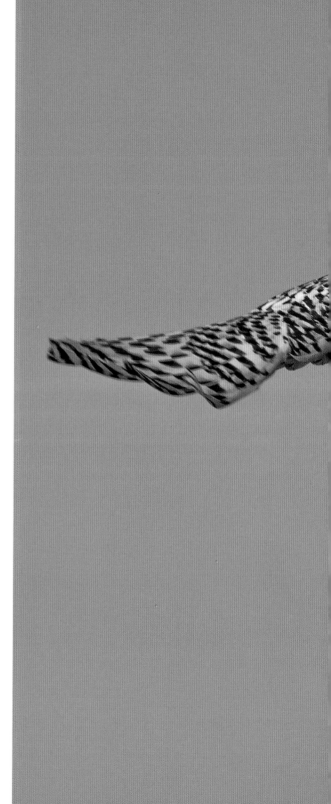

Above: Snowy owls spend most of their time in the far northern reaches of Canada and Alaska, nesting on the tundra. When their primary food, lemmings, is in short supply, they may migrate into the Pacific Northwest during the winter.

Right: The heavy barring on this snowy owl in flight indicates that it is a young female.

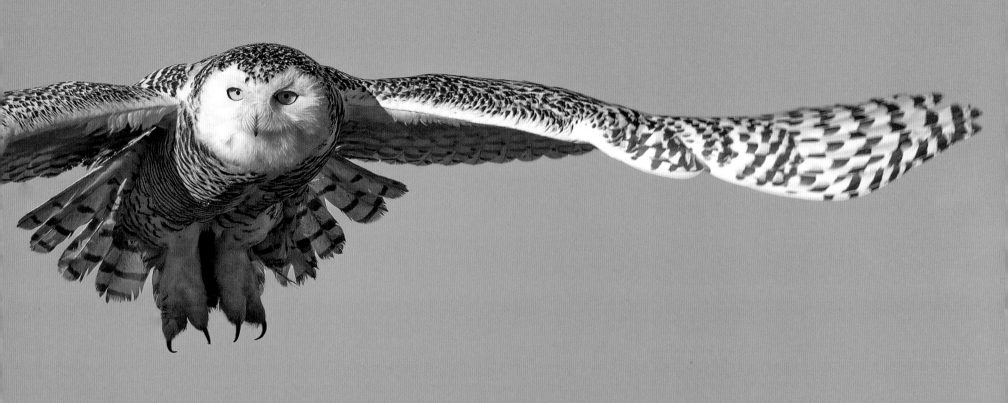

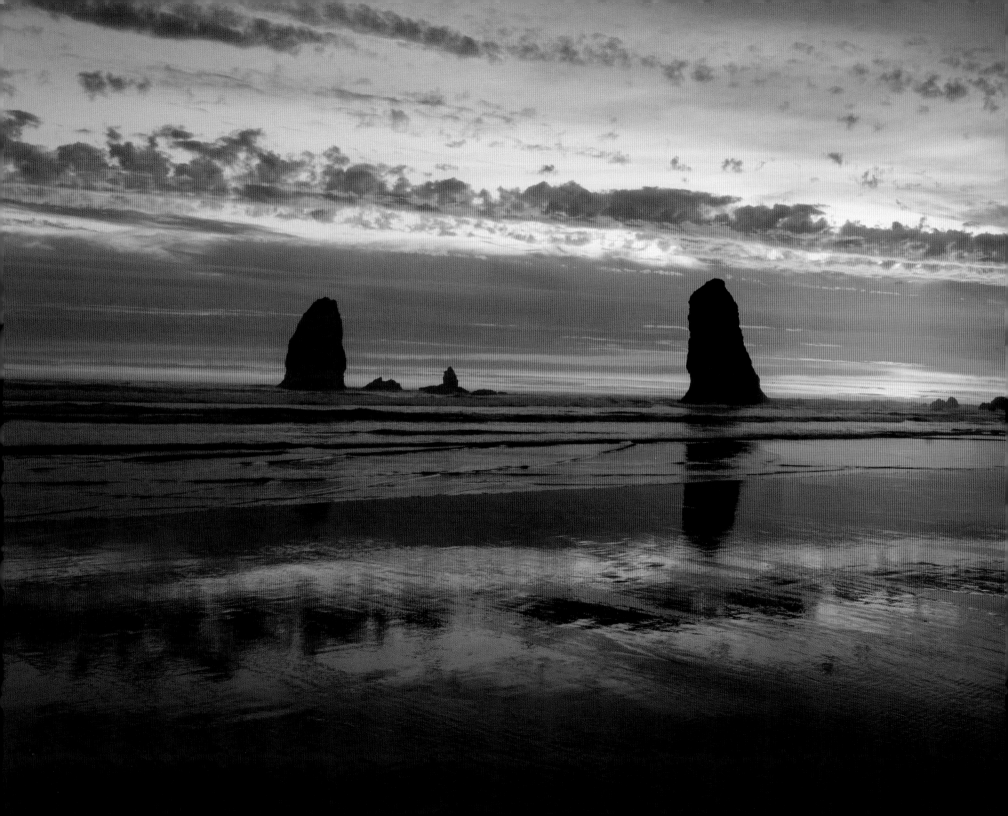

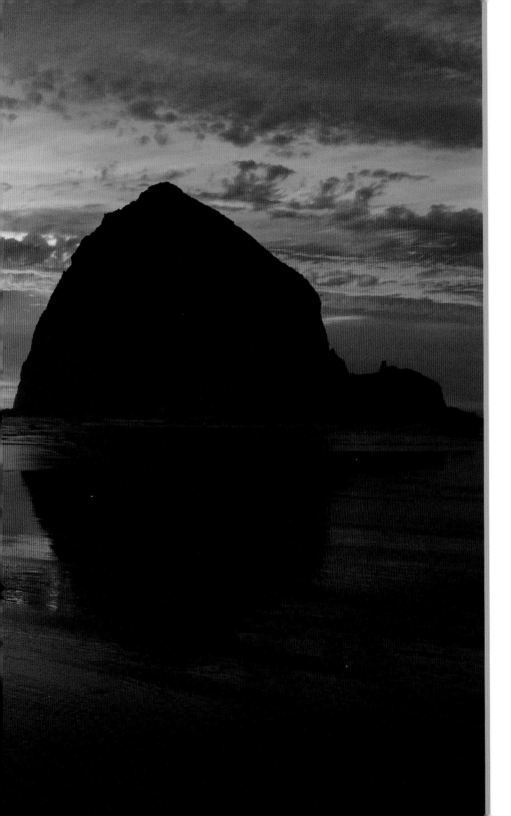

ISLAND AND OCEAN

By day, spending time on the beaches and islands of the Pacific Coast gives us energy. Ocean waves rhythmically pulse and fringe the shores with their noisy action. We gaze out across this vast habitat, hoping for a glimpse of a whale, wondering at the plethora of species that never surface.

By night, spending time on the coast has the opposite effect. It calms and slows our pace as we wonder at the kaleidoscope of color splashed across the sky and reflected below. The West Coast offers some of the best sunset photo opportunities anywhere in the world and the display is never repeated. Here, the sculptural rocks just off Oregon's Cannon Beach provide the ideal silhouette for a perfect sunset.

Above: Osprey bringing a fish to feed its young in the nest.

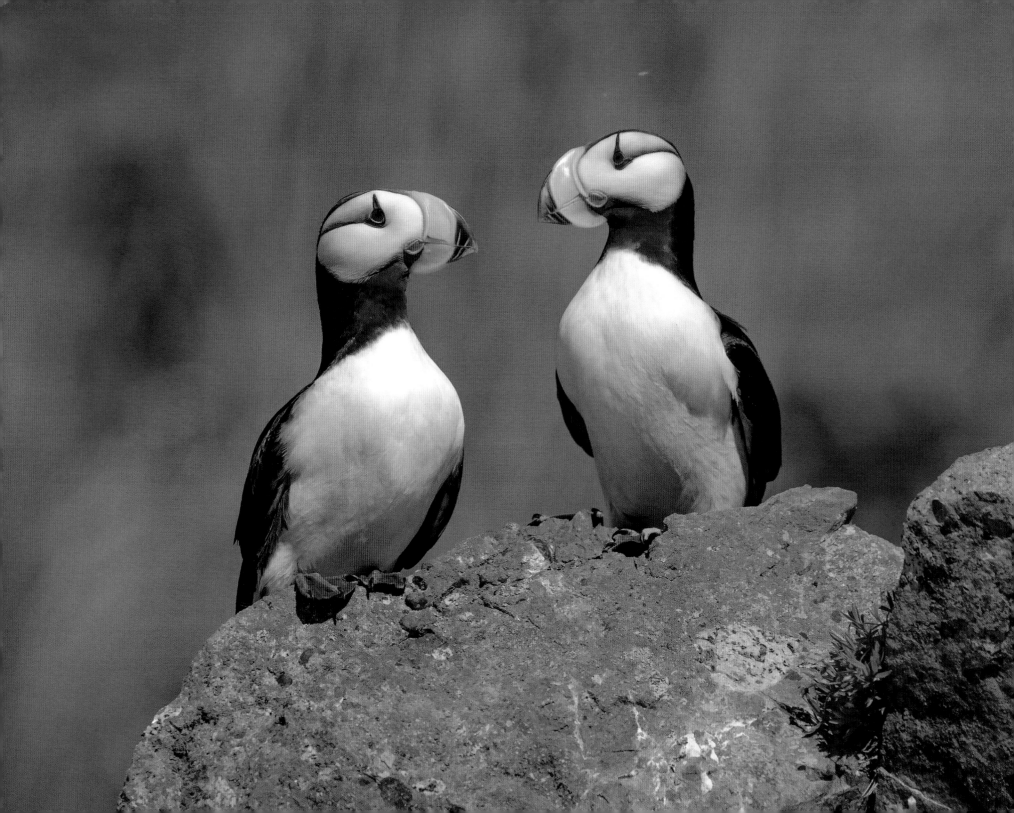

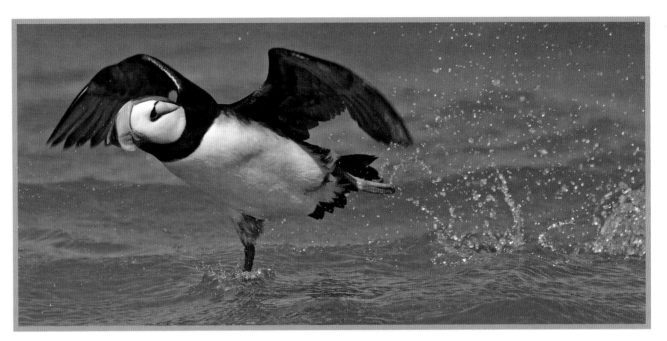

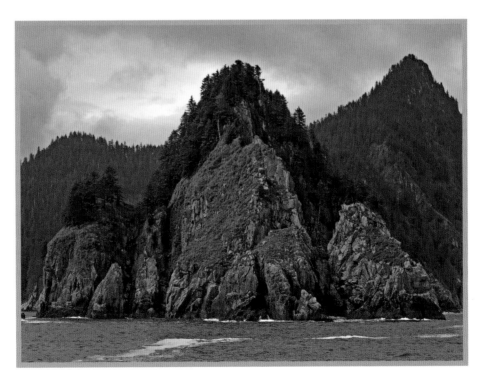

Above and Far Left: Horned puffins.

Left: Steep rocky islands along the Pacific Coast provide critical nesting habitat for horned puffins and other seabird species.

Next Pages: In Alaska's Lake Clark National Park a coastal brown bear patrols the shoreline waiting for low tide where it can dig clams.

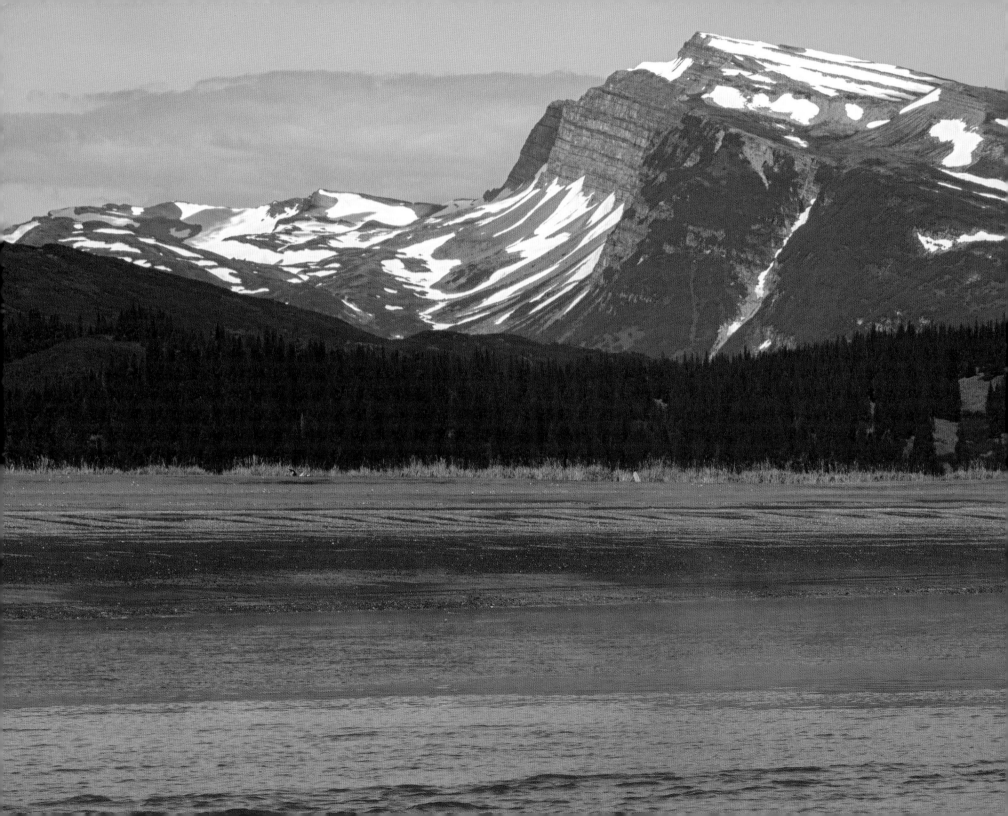

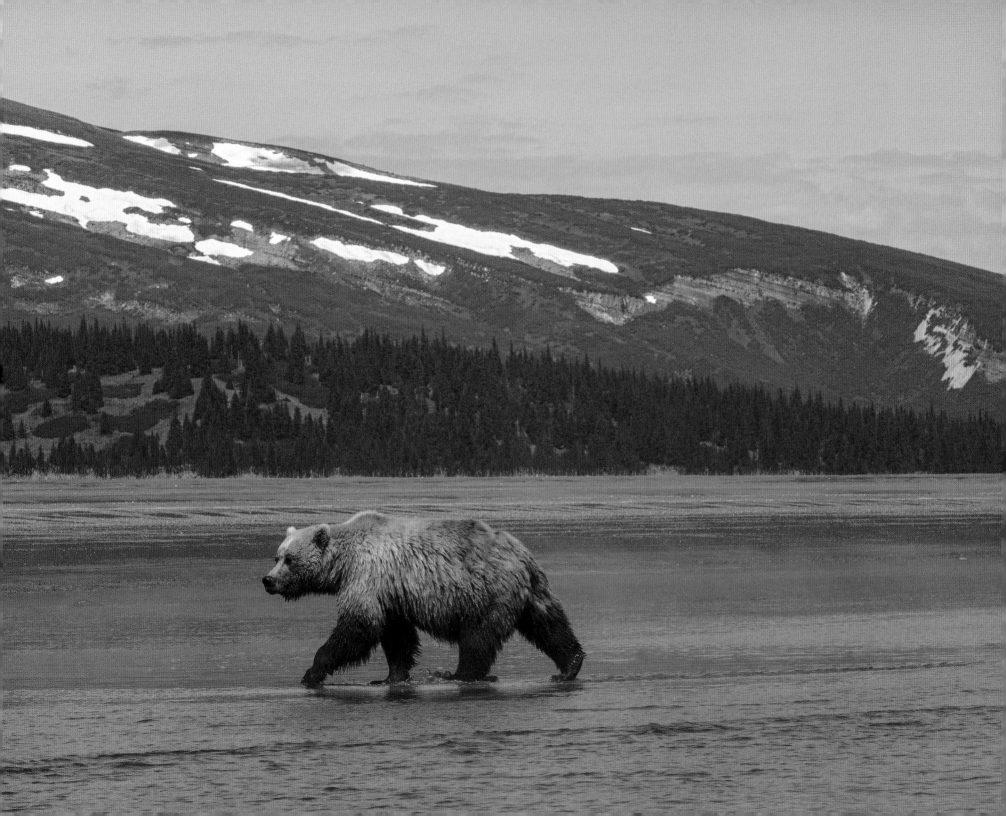

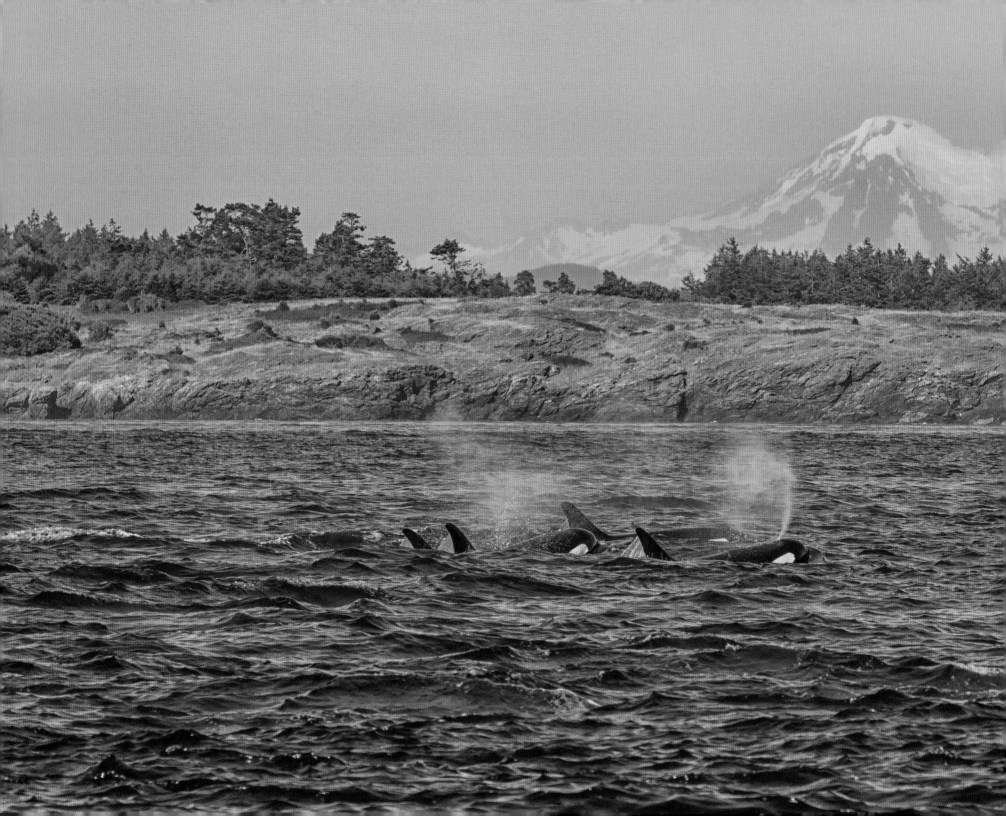

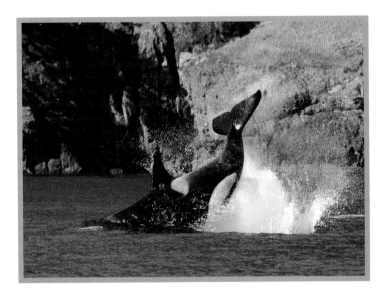
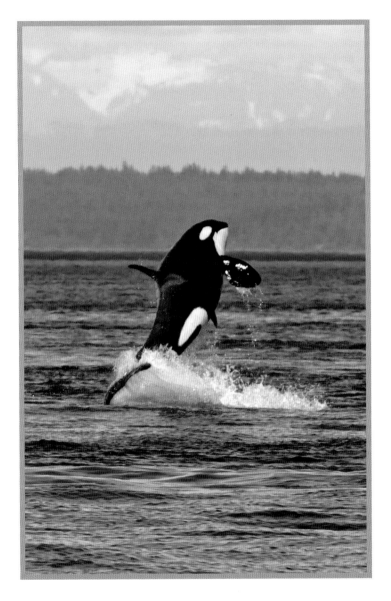
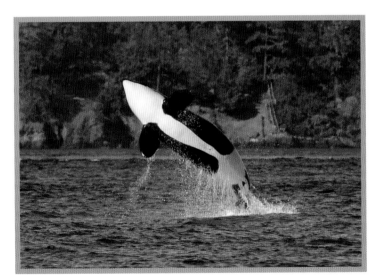

Left: Southern Resident Orca Whales spend part of the year living among the San Juan Islands between Washington State and Vancouver Island, British Columbia. They were added to the endangered species list in 1995. This was due to their primary food supply of king salmon being drastically lower than historical levels, the impact of the capture era of the 1960's and 70's for the purpose of captivity in marine parks, and increasing levels of pollution.

Top Left: Orca whale performing a fluke or tail slap.

Bottom Left and Right: Orca whale breaching. No one really knows why a whale leaps out of the water—to clean their skin, communicate, or play?

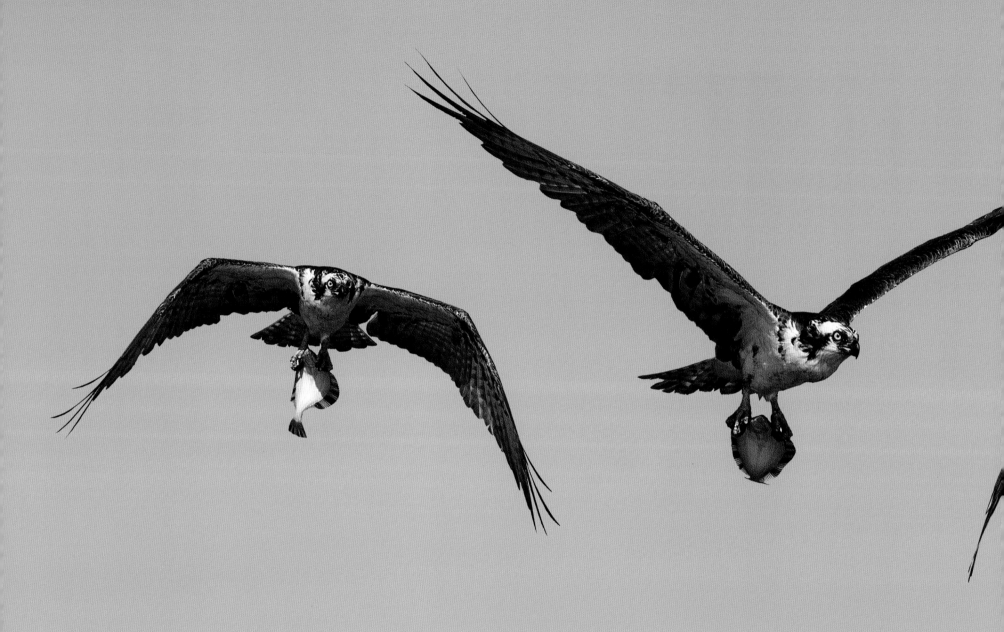

These four photographs of the same osprey illustrate the flight pattern of this bird that can be seen throughout the Pacific Northwest in summer months. It dives into the water feet first and has a reversible outer toe that allows it to carry fish, like this flounder, in its talons.

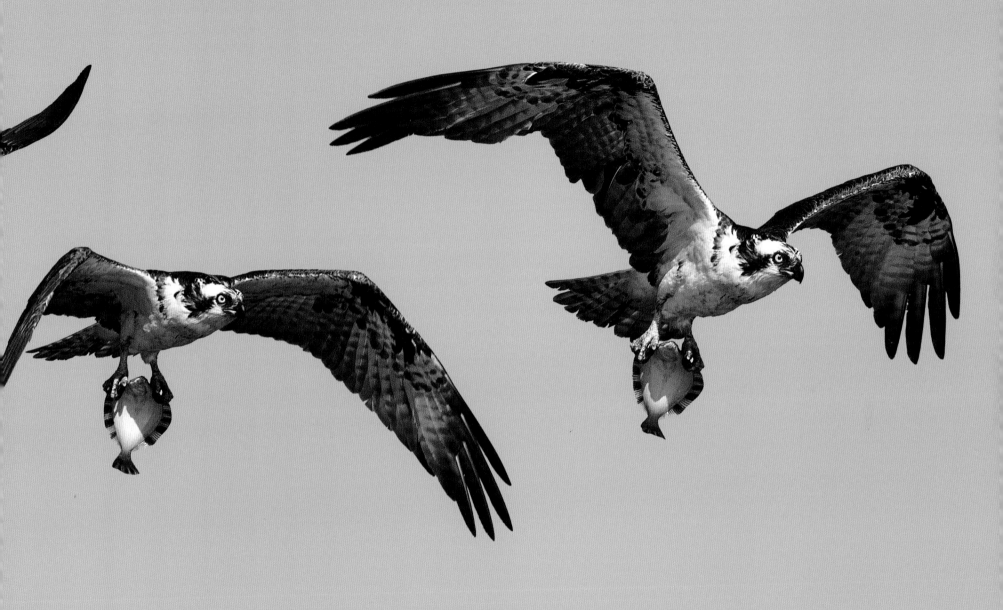

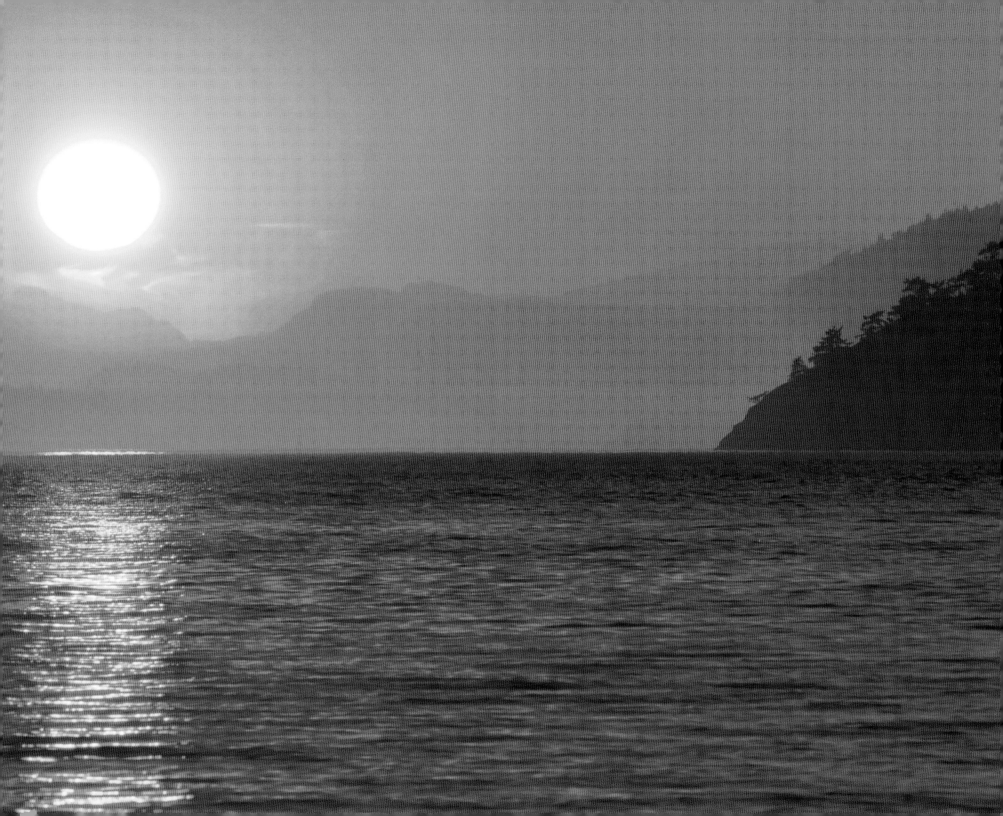

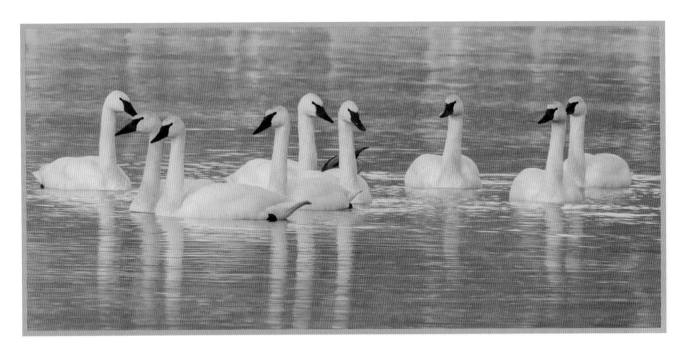

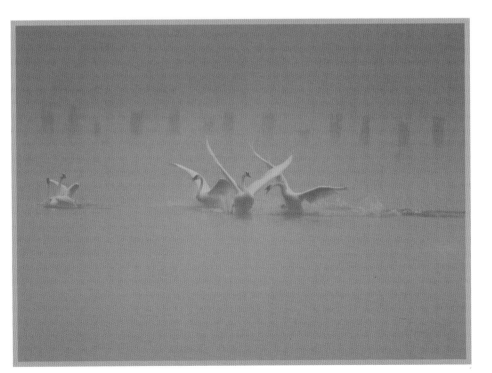

Above and Below: Trumpeter Swans are the largest waterfowl in North America. Humans nearly hunted them to extinction by the early 1900s but their population has rebounded as a result of conservation efforts.

Far Left: A photographer's dream—the magical and golden hour of sunset.

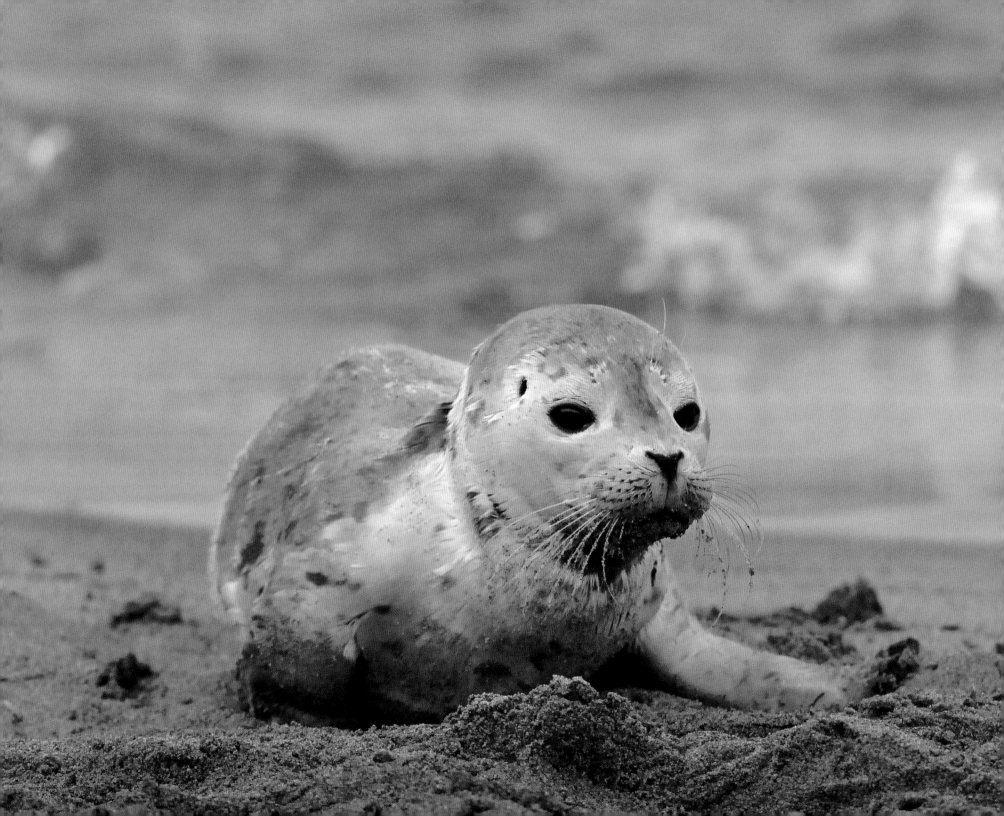

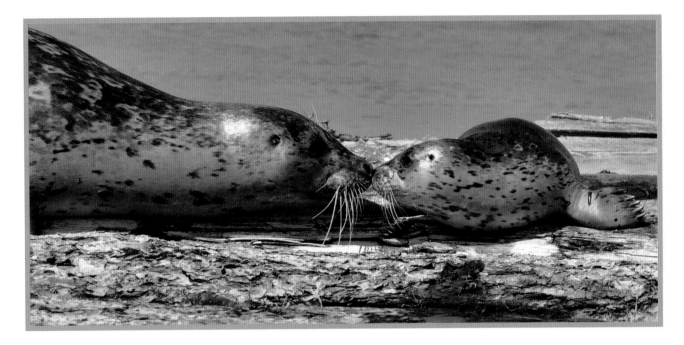

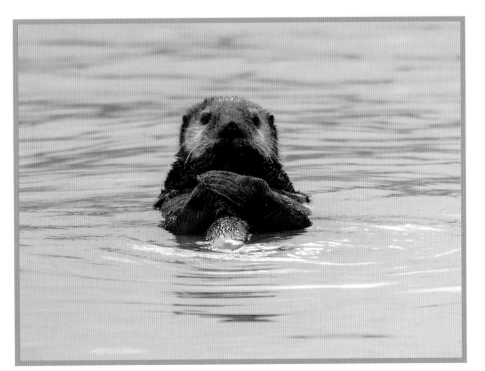

Above: A mother harbor seal shows affection to her pup.

Left: Unlike most marine mammals, the sea otter's primary form of insulation is an exceptionally thick coat of fur, the densest in the animal kingdom.

Far Left: A harbor seal pup rests on the beach waiting for its mother to return from hunting. Seals give birth in June and July.

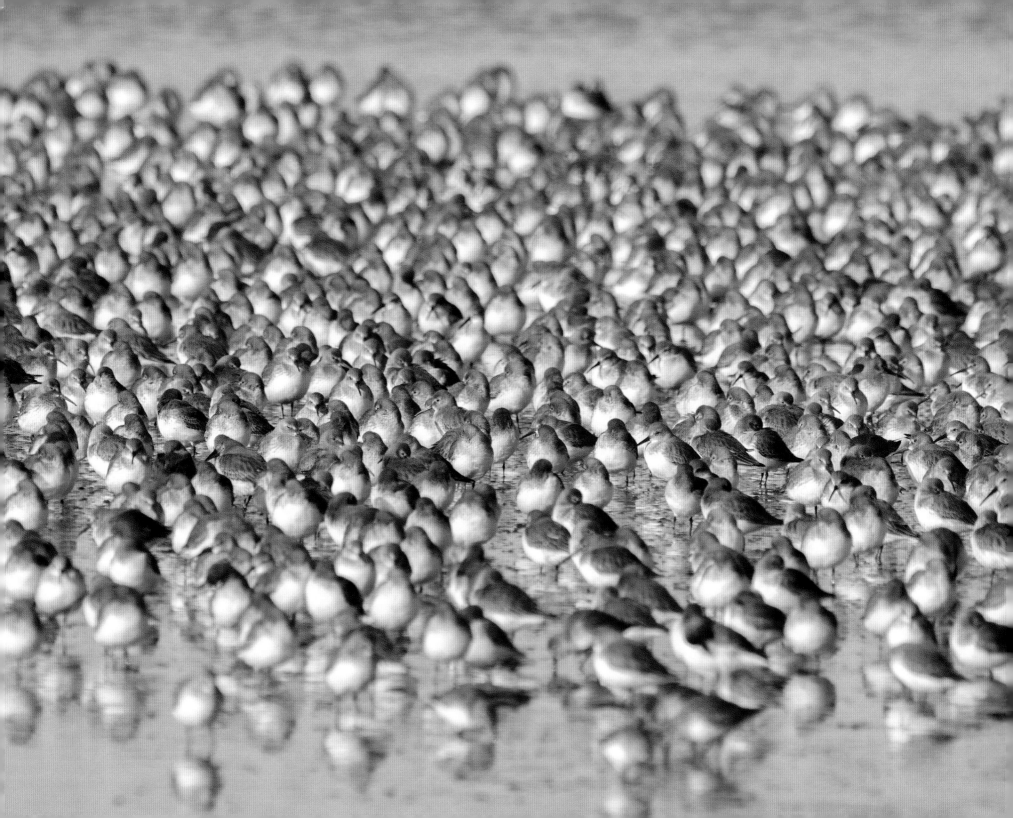

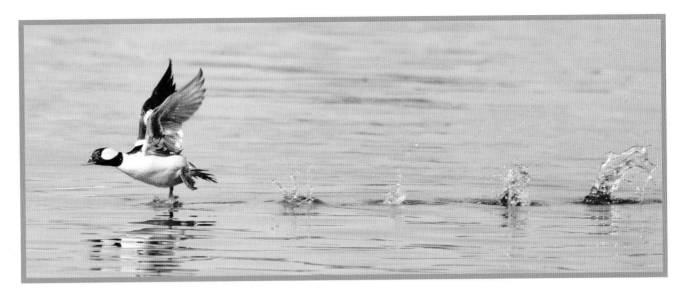

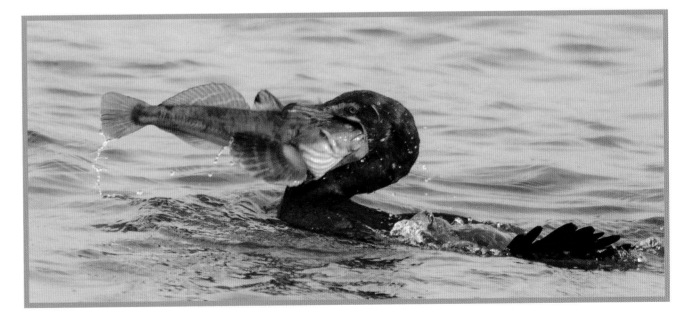

Top: A male bufflehead.

Bottom: A cormorant swallowing a fish. They dive and chase their prey underwater using powerful, webbed-feet propulsion.

Left: A large group of dunlin, a medium-sized sandpiper that winters along the northern Pacific Coast.

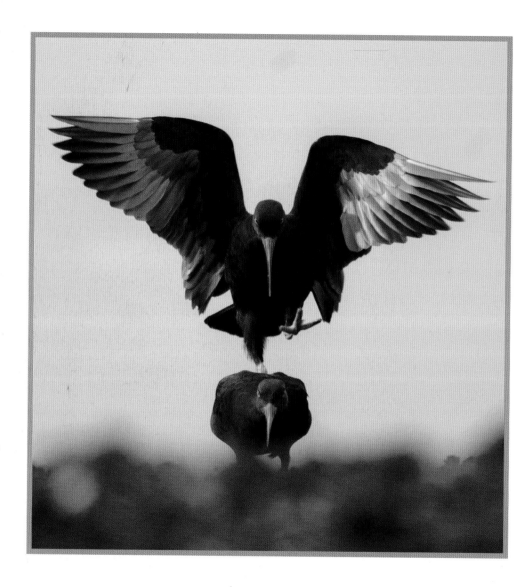

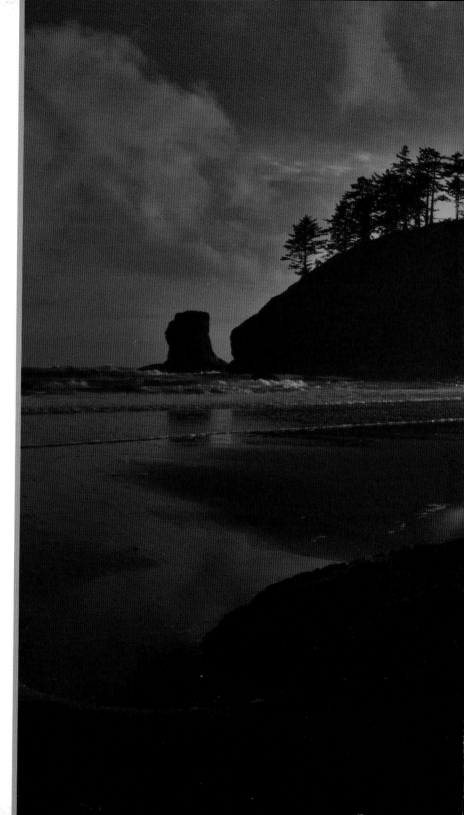

Above: A pair of black oystercatchers mating. They inhabit coastal areas from Alaska to Oregon. Whenever possible, I try to get eye level with my subjects to get a more intimate-looking photograph. I laid on my stomach on the rocky beach to get this image.

Right: Second Beach, Olympic National Park, during a tawny, nearly monochromatic, sunset. It is called Second Beach because of the headlands that block access between the area's three beaches, separating them.

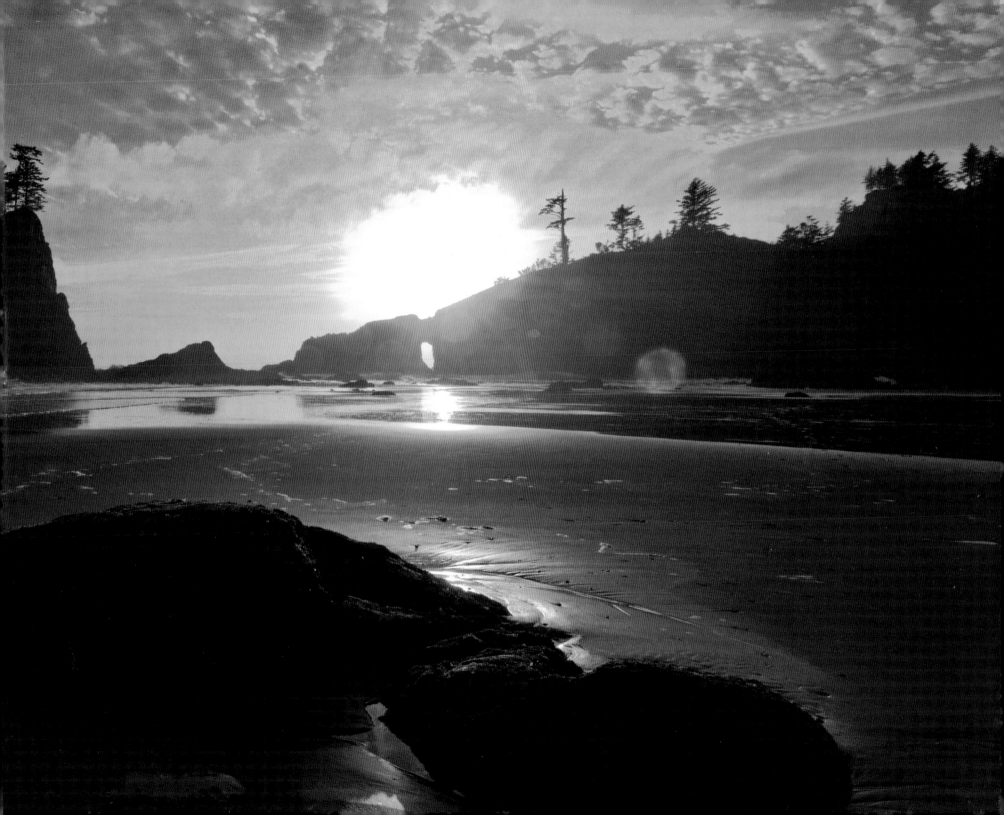

ACKNOWLEDGEMENTS

Thank you to all of the people who have worked passionately to protect these wild places, especially by promoting the creation of national parks and national wildlife refuges.

I'm grateful to all of the wonderful clients who have joined me on photo tours and workshops in the extraordinary Pacific Northwest and beyond.

This project would not have been possible without the following people and I would like to extend a special thank you to: Ed and Lorraine Doyne, Bryan and Melinda Baggenstos, Todd Steitle, Michael Rohani, Bryan and Christina Norlien, Patrica Wampler, Greg Hensen, Duke Coonrad, Mick Thompson, Rebecca Willow, Melissa Hahn, Brian Scheele, and Karen Reinhart.

ABOUT THE AUTHOR

Aaron Baggenstos is an award-winning professional wildlife photographer who currently resides in the Seattle area. Aaron has captured images across North America, South America, Europe, and Africa but specializes in his home, the Pacific Northwest. His photographs and videos have been featured in television shows and newscasts, in books, magazines, and numerous web articles. Aaron invites you to join him on photographic tours and workshops at exciting locations throughout the Pacific Northwest. For more information visit www.AaronsTours.com.